MARGARET BOURKE-WHITE

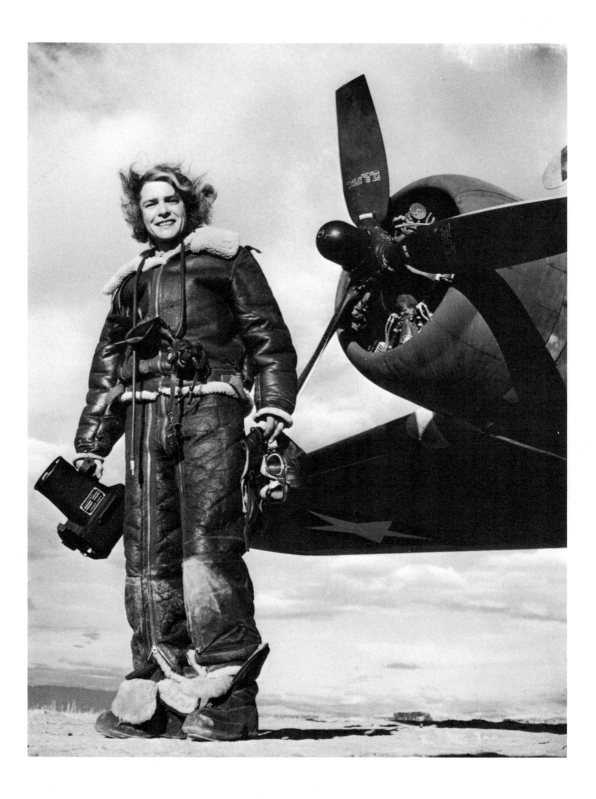

AMERICAN WOMEN of ACHIEVEMENT

MARGARET BOURKE-WHITE

CAROLYN DAFFRON

CHELSEA HOUSE PUBLISHERS

NEW YORK • PHILADELPHIA

EDITOR-IN-CHIEF: Nancy Toff
EXECUTIVE EDITOR: Remmel T. Nunn
MANAGING EDITOR: Karyn Gullen Browne
COPY CHIEF: Juliann Barbato
PICTURE EDITOR: Adrian G. Allen
ART DIRECTOR: Giannella Garrett
MANUFACTURING MANAGER: Gerald Levine

Staff for MARGARET BOURKE-WHITE

SENIOR EDITOR: Constance Jones
COPYEDITOR: Terrance Dolan
DEPUTY COPY CHIEF: Ellen Scordato
EDITORIAL ASSISTANT: Theodore Keyes
PICTURE RESEARCHER: Faith Schornick
DESIGNER: Design Oasis
ASSISTANT DESIGNER: Donna Sinisgalli
PRODUCTION COORDINATOR: Joseph Romano
COVER ILLUSTRATOR: Richard Leonard

CREATIVE DIRECTOR: Harold Steinberg

3 5 7 9 8 6 4

Library of Congress Cataloging in Publication Data

Daffron, Carolyn.

Margaret Bourke-White.

(American women of achievement)
Bibliography: p.
Includes index.
Summary: A biography of the woman who became a staff photog-
rapher for *Life* magazine and served overseas as a correspondent
during World War II and the Korean War.
1. Bourke-White, Margaret, 1904–1971—Juvenile Literature.
2. Photographers—United States—Biography—Juvenile
literature. 3. Women photographers—United States—
Biography—Juvenile literature [1. Bourke-White, Margaret,
1904–1971. 2. Photographers] I. Title. II. Series
TR140.B6D34 1988 770'.92'4 [B] [92] 87-25685

ISBN 1-55546-644-3
 0-7910-0411-2 (pbk.)

CONTENTS

AMERICAN WOMEN of ACHIEVEMENT

Abigail Adams
women's rights activist

Jane Addams
social worker

Louisa May Alcott
author

Marian Anderson
singer

Susan B. Anthony
woman suffragist

Ethel Barrymore
actress

Clara Barton
founder of the American Red Cross

Elizabeth Blackwell
physician

Nellie Bly
journalist

Margaret Bourke-White
photographer

Pearl Buck
author

Rachel Carson
biologist and author

Mary Cassatt
painter

Agnes De Mille
choreographer

Emily Dickinson
poet

Isadora Duncan
dancer

Amelia Earhart
aviator

Mary Baker Eddy
founder of the Christian Science church

Betty Friedan
feminist

Althea Gibson
tennis champion

Emma Goldman
revolutionary

Helen Hayes
actress

Lillian Hellman
playwright

Katharine Hepburn
actress

Karen Horney
psychoanalyst

Anne Hutchinson
religious leader

Mahalia Jackson
gospel singer

Helen Keller
humanitarian

Jeane Kirkpatrick
diplomat

Emma Lazarus
poet

Clare Boothe Luce
author and diplomat

Barbara McClintock
biologist

Margaret Mead
anthropologist

Edna St. Vincent Millay
poet

Julia Morgan
architect

Grandma Moses
painter

Louise Nevelson
sculptor

Sandra Day O'Connor
Supreme Court Justice

Georgia O'Keeffe
painter

Eleanor Roosevelt
diplomat and humanitarian

Wilma Rudolph
champion athlete

Florence Sabin
physician

Beverly Sills
singer

Gertrude Stein
author

Gloria Steinem
feminist

Harriet Beecher Stowe
author and abolitionist

Mae West
entertainer

Edith Wharton
author

Phillis Wheatley
poet

Babe Zaharias
champion athlete

CHELSEA HOUSE PUBLISHERS

"Remember the Ladies"

MATINA S. HORNER

Remember the Ladies." That is what Abigail Adams wrote to her husband John, then a delegate to the Continental Congress, as the Founding Fathers met in Philadelphia to form a new nation in March of 1776. "Be more generous and favorable to them than your ancestors. Do not put such unlimited power in the hands of the Husbands. If particular care and attention is not paid to the Ladies," Abigail Adams warned, "we are determined to foment a Rebellion, and will not hold ourselves bound by any Laws in which we have no voice, or Representation."

The words of Abigail Adams, one of the earliest American advocates of women's rights, were prophetic. Because when we have not "remembered the ladies," they have, by their words and deeds, reminded us so forcefully of the omission that we cannot fail to remember them. For the history of American women is as interesting and varied as the history of our nation as a whole. American women have played an integral part in founding, settling, and building our country. Some we remember as remarkable women who—against great odds—achieved distinction in the public arena: Anne Hutchinson, who in the 17th century became a charismatic religious leader; Phillis Wheatley, an 18th-century black slave who became a poet; Susan B. Anthony, whose name is synonymous with the 19th-century women's rights movement, and who led the struggle to enfranchise women; and, in our own century, Amelia Earhart, the first woman to cross the Atlantic Ocean by air.

These extraordinary women certainly merit our admiration, but other women, "common women," many of them all but forgotten, should also be recognized for their contributions to American thought and culture. Women have been community builders; they have founded schools and formed voluntary associations to help those in need; they have assumed the major responsibility for rearing children, passing on from one generation to the next the values that keep a culture alive. These and innumerable other contributions, once ignored, are now being recognized by scholars, students, and the public. It is exciting and gratifying to realize that a part of our history that was hardly acknowledged a few generations ago is now being studied and brought to light.

In recent decades, the field of women's history has grown from obscurity to a politically controversial splinter movement to academic respectability, in many cases mainstreamed into such traditional disciplines as history, economics, and psychology. Scholars of women, both female and male, have organized research centers at such prestigious institutions as Wellesley College, Stanford University, and the University of California. Other notable centers for women's studies are the Center for the American Woman and Politics at the Eagleton Institute of Politics at Rutgers University; the Henry A. Murray Research Center for the Study of Lives, at Radcliffe College; and the Women's Research and Education Institute, the research arm of the Congressional Caucus on Women's Issues. Other scholars and public figures have established archives and libraries, such as the Schlesinger Library on the History of Women in America, at Radcliffe College, and the Sophia Smith Collection, at Smith College, to collect and preserve the written and tangible legacies of women.

From the initial donation of the Women's Rights Collection in 1943, the Schlesinger Library grew to encompass vast collections documenting the manifold accomplishments of American women. Simultaneously, the women's movement in general and the academic discipline of women's studies in particular also began with a narrow definition and gradually expanded their mandate. Early causes such as woman suffrage and social reform, abolition and organized labor were joined by newer concerns such as the history of women in business and the professions and in politics and government; the study of the family; and social issues such as health policy and education.

Women, as historian Arthur M. Schlesinger, jr., once pointed out, "have constituted the most spectacular casualty of traditional history. They have made up at least half the human race, but you could never tell that by looking at the books historians write." The new breed of historians is remedying that

omission. They have written books about immigrant women and about working-class women who struggled for survival in cities and about black women who met the challenges of life in rural areas. They are telling the stories of women who, despite the barriers of tradition and economics, became lawyers and doctors and public figures.

The women's studies movement has also led scholars to question traditional interpretations of their respective disciplines. For example, the study of war has traditionally been an exercise in military and political analysis, an examination of strategies planned and executed by men. But scholars of women's history have pointed out that wars have also been periods of tremendous change and even opportunity for women, because the very absence of men on the home front enabled them to expand their educational, economic, and professional activities and to assume leadership in their homes.

The early scholars of women's history showed a unique brand of courage in choosing to investigate new subjects and take new approaches to old ones. Often, like their subjects, they endured criticism and even ostracism by their academic colleagues. But their efforts have unquestionably been worthwhile, because with the publication of each new study and book another piece of the historical patchwork is sewn into place, revealing an increasingly comprehensive picture of the role of women in our rich and varied history.

Such books on groups of women are essential, but books that focus on the lives of individuals are equally indispensable. Biographies can be inspirational, offering their readers the example of people with vision who have looked outside themselves for their goals and have often struggled against great obstacles to achieve them. Marian Anderson, for instance, had to overcome racial bigotry in order to perfect her art and perform as a concert singer. Isadora Duncan defied the rules of classical dance to find true artistic freedom. Jane Addams had to break down society's notions of the proper role for women in order to create new social institutions, notably the settlement house. All of these women had to come to terms both with themselves and with the world in which they lived. Only then could they move ahead as pioneers in their chosen callings.

Biography can inspire not only by adulation but also by realism. It helps us to see not only the qualities in others that we hope to emulate, but also, perhaps, the weaknesses that made them "human." By helping us identify with the subject on a more personal level they help us to feel that we, too, can achieve such goals. We read about Eleanor Roosevelt, for instance, who occupied a unique and seemingly enviable position as the wife of the president. Yet we can sympathize with her inner dilemma: an inherently shy

woman, she had to force herself to live a most public life in order to use her position to benefit others. We may not be able to imagine ourselves having the immense poetic talent of Emily Dickinson, but from her story we can understand the challenges faced by a creative woman who was expected to fulfill many family responsibilities. And though few of us will ever reach the level of athletic accomplishment displayed by Wilma Rudolph or Babe Zaharias, we can still appreciate their spirit, their overwhelming will to excel.

A biography is a multifaceted lens. It is first of all a magnification, the intimate examination of one particular life. But at the same time, it is a wide-angle lens, informing us about the world in which the subject lived. We come away from reading about one life knowing more about the social, political, and economic fabric of the time. It is for this reason, perhaps, that the great New England essayist Ralph Waldo Emerson wrote, in 1841, "There is properly no history: only biography." And it is also why biography, and particularly women's biography, will continue to fascinate writers and readers alike.

MARGARET BOURKE-WHITE

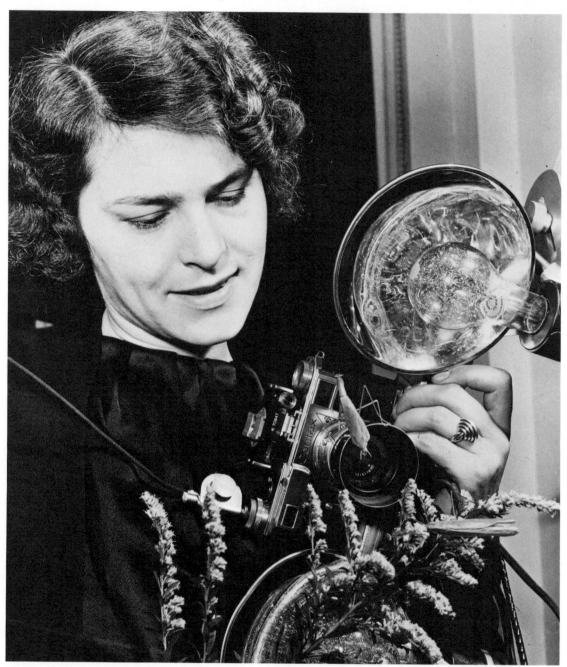

Renowned as much for her adventurous spirit as for her remarkable talent, Margaret Bourke-White photographed everything from insects to fighter planes during her prolific career.

ONE

"You Have Seen Their Faces"

One morning in early 1936, photographer Margaret Bourke-White had a nightmare. Huge, terrifying shapes rushed toward her on a zigzag course, trying to run her down, to crush her. The faster she ran, the more surely they bore down on her. When the dark shapes came closer, she recognized them as the Buick cars she had photographed during the day as part of her advertising work. The cars towered above her, their hoods open at jagged angles as if to swallow her up, and she awoke to find that she had fallen out of bed and was writhing on the floor, her back strained with tension.

Bourke-White interpreted her nightmare as a sign of the serious conflict she felt over the direction of her career. At 31, she was already a brilliantly successful photographer, famed for her pioneering work in capturing the drama of industry. Her photographs had allowed people to see the hidden beauty and majesty of steel mills, giant factory dynamos, skyscrapers—even

hog farms. Bourke-White, the first Westerner allowed to photograph Soviet Russia, had traveled throughout the country and the world. Her courage and single-mindedness were legendary: All over America, people had read about the beautiful, dashing "girl photographer" who would dangle from high ledges, crawl down into mine shafts where no woman (and no camera) had gone before, and even stand in the path of molten steel to get the exact picture she wanted.

Bourke-White found the mid-1930s an exciting time to be a photographer. Just a few years earlier, most photographs had been formally posed shots, taken under bright lights with heavy, slow equipment. But, thanks to new technology and new ideas, photographers had started using their cameras to record almost every aspect of life, capturing real moments of time instead of orchestrating artificial ones. For the first time, photographs played an important role in magazine report-

ing, and Bourke-White had become one of the foremost magazine photographers in the world, a mainstay of prestigious *Fortune* magazine. For several years she had been splitting her time between the work she did for *Fortune*, which printed a series of her photos in almost every issue, and the glossy advertising photographs she shot in her own penthouse studio in Manhattan.

Yet, as her nightmare revealed, she was deeply troubled about the style and subjects of her photography, especially about the work she did to fulfill ad contracts—work that supported her expensive private studio. Two years earlier, on a *Fortune* assignment, she had flown across the Midwest recording the horrible effects of the Dust Bowl drought, which had turned rich farmland into desert and left hundreds of thousands of Americans in poverty and despair. After witnessing this national tragedy, she found it unfulfilling to return to the empty, artificial world of advertising.

Soon after her Dust Bowl assignment, she had spent hours working on a contract for one of her biggest advertising accounts, a tire company. To create the idealized picture her client wanted—an enormous tire leaving deep tracks in the desert—she had to use a fake, oversized tire, toy cars that made the tire look even bigger, a special stamp that produced phony tire tracks, and even imitation sand. As she wrote in her autobiography, she "longed to see the real world behind the real tire . . . where things did not have to look convincing, they just had to be true."

On the morning after her dream, Bourke-White resolved that she would never again accept an assignment unless she could complete it in a creative, honest, useful way. That very afternoon, an ad agency called the studio and asked her to take five photographs. The agency offered a fee of $1,000 for each picture, more than Bourke-White had ever received for a single photograph, and a phenomenal sum of money in those days, when the Great Depression was at its height. (With one-fourth of the nation unemployed, many of those who had jobs earned less than $1,000 for a whole year's work.) But Bourke-White hesitated only for a moment before refusing the assignment. Within weeks she had begun taking steps to close her commercial studio.

Once she had resolved to get out of the advertising business, Bourke-White realized that she wanted to make an even more basic change in her work. Since her earliest days as a photographer she had been fascinated by machines, architecture, and nature—by abstract shapes and rhythms—by *objects*. But after her trip through the Dust Bowl, she felt for the first time a

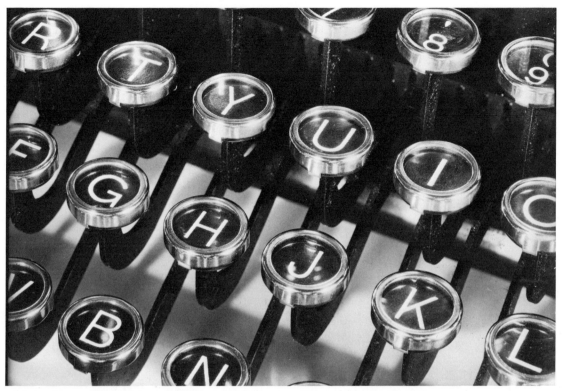

Although Bourke-White's ability to convey the grace of everyday objects such as this Royal typewriter won her many advertising jobs, she eventually decided to give up this lucrative but unsatisfying work.

need to get out into America to see and record the experiences of its *people*. As it did for many photographers, artists, and writers in the 1930s, the depression awakened her social conscience.

Bourke-White longed to do a thorough study of some aspect of her fellow Americans' lives—not just the usual four or five photographs for a magazine assignment, but a full-length book that would combine photographs and text. But, although she would later prove her literary talent, she did not consider herself a writer at that time. She began looking for a collaborator for her project, someone who wanted to express with words what she wanted to express with black-and-white pictures.

Within a week or two she learned that Erskine Caldwell, the distinguished author of several books, had a similar project in mind and had been looking for a photographer. It seemed

as if fate had sent her the ideal partner just when she needed him most.

Caldwell, a southern author, had written the novel *Tobacco Road*, which had been adapted into one of the most popular and controversial plays on Broadway in the 1930s. Caldwell had been dismayed by criticism that he had falsely portrayed the poverty and degradation of the rural American South in *Tobacco Road*, and that he had exaggerated the characters and conditions the novel described. He hoped that a nonfiction book, with photographs, would convince people that life among poor southern farmers was as terrible as *Tobacco Road* implied.

When she and Caldwell met, Bourke-White was surprised to discover that the author of such savage and powerful books was a large, shy, gentle-spoken man. Even his coloring—faded blue eyes, subdued reddish hair, pale freckled skin—seemed quiet. Physically and temperamentally, Bourke-White was Caldwell's opposite: She was dramatic and colorful, slender and always on the move. Her wide smile dazzled, her blue eyes shone, she wore chic and daring clothes, and her prematurely graying hair only made her appear younger and more startlingly attractive. She found Caldwell's looks and manner a bit disappointing, and thought to herself that he would be a dull and humorless collaborator.

Caldwell, for his part, had doubts about the flamboyant Bourke-White. He had heard that she insisted on having everything her own way, and he suspected that she would be unreliable. He did not even like her photographs much—especially the glossy advertisements. Nevertheless, Caldwell wanted to work with the most talented and respected partner available, and Bourke-White did, too. So they set a date—five months later, in June of 1936—to begin work. They planned to meet again in Augusta, Georgia, in the lobby of its best hotel. From there they would travel in Caldwell's Ford across the tobacco- and cotton-growing areas of the Deep South.

The project did not get off to a very promising start. In the five months before their planned meeting, Bourke-White had closed down her commercial studio and begun what would be a lifelong association with *Life* magazine, which started publication that year—with a Bourke-White photo for its first cover. Her magazine commitments kept her so busy that she called Caldwell in Georgia to ask whether they might postpone their meeting for a week or so; he responded by saying that maybe they should just abandon the project. But Bourke-White could not bear to give up on their idea. When she found that she could not change Caldwell's mind by letter or telephone, she decided to pack for the trip as if nothing had happened. Bourke-White

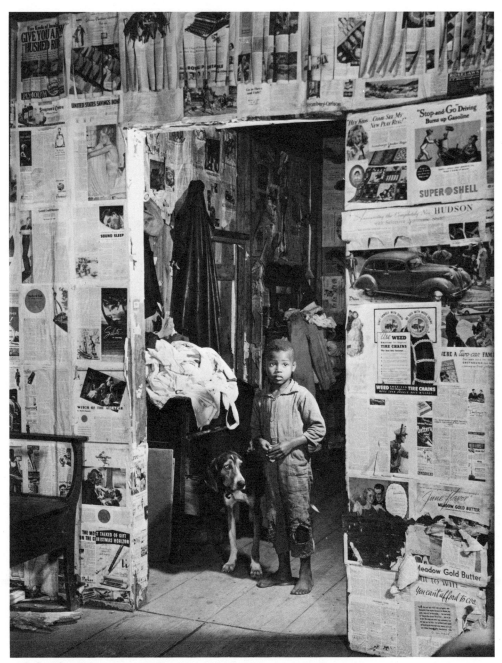

While shooting You Have Seen Their Faces, *Bourke-White observed that in many impoverished southern households—like this one in Louisiana—people had discovered a practical use for magazine advertisements.*

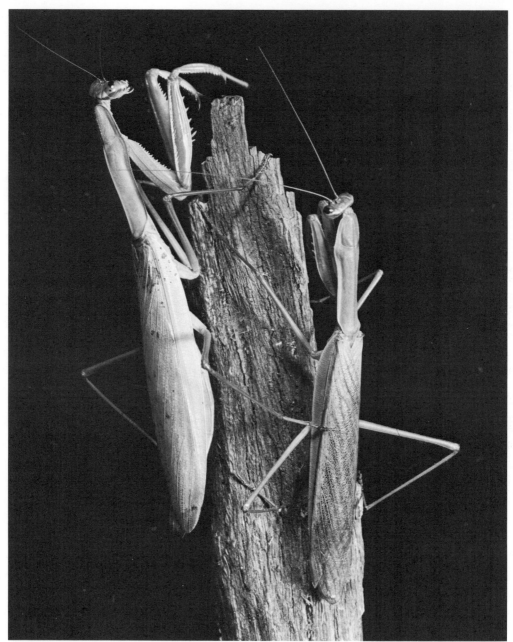

Bourke-White recorded images of unspeakable poverty on her trip through the South but enjoyed a moment of eerie beauty when the praying mantis eggs she was carrying hatched.

flew down to Georgia, checked into the agreed-upon hotel, and wrote Caldwell a letter saying that she had arrived and imploring him to reconsider. She found a boy with a bicycle and paid him to deliver her message to Caldwell, who was staying at his parents' house a few miles away.

She waited in the hotel lobby for 10 hours before Caldwell finally sauntered in. Accounts differ as to how she managed it, but Bourke-White somehow convinced him to go ahead with the trip. They set out that same evening in a car overloaded with bulky camera equipment, suitcases, and two jars of praying mantis eggs, which Bourke-White had been carefully photographing for several weeks.

For the next few days, Bourke-White, Caldwell, and the literary secretary he had hired for the trip meandered along back roads from Georgia to Arkansas. Bourke-White, thrilled to have embarked on the journey, felt certain that Caldwell would widen her horizons by helping her look at the South through his experienced eyes. True, he had been silent and enigmatic so far, and she had only heard him laugh with real pleasure once—when the trunk of the car had crashed down on Bourke-White's head while she was tending her mantis eggs. But Bourke-White was positive that everything would work out—her father had been a taciturn man much like Caldwell, and she had

learned to live with him. Caldwell flabbergasted her when, five days into the trip, he told her that he doubted whether they would ever get anywhere. He suggested that they give up and go their separate ways.

In her autobiography, Bourke-White recalls what happened next:

> I tried desperately to tell him how much this meant to me, this opportunity to do something worthwhile, but I wasn't making much sense because, of course, I was crying. Then suddenly something very unexpected happened. He fell in love with me... From now on, there were no more surprises, except personal and pleasant ones. The work was flowing on, a wide stream, with the deepening understanding between us.

Sources close to Caldwell offer a somewhat different version of what occurred that night. In her biography of Bourke-White, Vicki Goldberg reports that Caldwell's literary secretary and his agent (who credits Caldwell himself as his source) both claim that Bourke-White seduced Caldwell in order to keep him from abandoning the project. Whatever their original feelings or motives, Caldwell and Bourke-White—or "Skinny" and "Kit," as they called each other—were soon very much in love.

Throughout that summer and part of the following spring, Bourke-White and Caldwell drove across the South together, stopping at hundreds of towns, villages, and farms along the

way, meeting as many people as they could. Caldwell did most of the talking. With his southern background and accent, it was easier for him to gain his listeners' trust. He also had a gift for making friends with strangers. Bourke-White learned a great deal from watching her new partner at work. He respected his subjects and knew that he would find out more by listening than by talking.

While Caldwell was getting to know people—hanging over a back fence perhaps, or sitting on the porch of a general store—Bourke-White would use one of her smaller cameras to take outdoor shots, trying to remain as unobtrusive as possible. Once Caldwell and his new acquaintances had established a rapport, they would usually give Bourke-White permission to set up her bulkier equipment for close-up portraits, and perhaps even invite her indoors to take more pictures. Photographic technology at the time required Bourke-White to use a daunting array of equipment in order to get the portraits and indoor shots she wanted: several heavy cameras, each with its own tripod; bright photographer's lights; and flashbulbs that made small explosions when they went off.

Bourke-White was appalled by the human misery she saw in the rural South. Some 10 million southerners lived on sharecrop farms, working on land they did not own and giving their landlords part of the annual crop as rent. Many sharecroppers, white and black, lived in virtual slavery, falling deeper in debt to their landlords every year and subject to arrest if they tried to leave the plot of overworked soil that they knew would never support their families decently. Bourke-White met families who survived all year on nothing more than a small supply of cornmeal and molasses. She learned that poor farmers often bought snuff before buying food, because tobacco could dull the pain of rotting teeth and empty stomachs. And she saw the ugliness of racism, including the fury of a lynch mob that only called off its hanging when the sheriff arrived. She and Caldwell took care to record the experiences of both races in their book. For the rest of her life, Bourke-White strongly opposed racial inequality.

In the poorest parts of the countryside, Bourke-White was amazed to see that the sharecroppers had found a practical use for advertising photographs. To insulate their one-room shacks, they papered the bare wood inside and out with old newspapers, magazines, and billboard posters, most of them advertising luxuries the families who lived there could never afford. When she saw these miserable shacks—many without beds or windows, much less plumbing or electricity—Bourke-White often had the uneasy feeling that she would find some

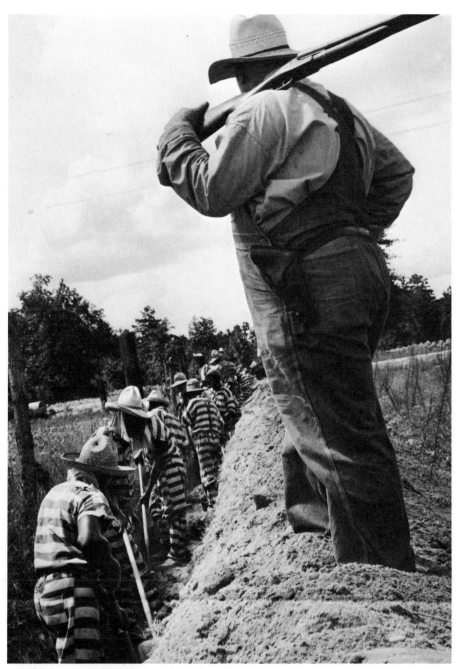

Undiscouraged by her confrontation with a threatening prison officer, Bourke-White obtained permission to photograph one of the chain gangs common in the South at the time.

of her own glossy ads on the walls if she looked hard enough. In one such house, Bourke-White met a little girl named Begonia who could only go to school every other day because she had to share a coat and a pair of old shoes with her twin sister. Bourke-White would never forget Begonia's wistful face, seen against a background of bright magazine ads for a whole range of beautiful clothes.

Much of what they saw angered and saddened Caldwell and Bourke-White. But they found their work, and each other, endlessly exciting, so their travels through the South also brought joy. One afternoon, for example, as they stopped along a country road, Bourke-White discovered that her praying mantis eggs were finally hatching. Bourke-White arranged her egg cases on a split-log fence, the perfect backdrop for her photographs. As always, once she started taking pictures, Bourke-White became completely caught up in her work, watching as 200 of the delicate insects climbed out into the light and air. Only when she had finished did she notice the ring of little children who had silently gathered to watch. When they saw the baby mantises, the children started to sing: "Look at the little devil horses! Oh, look at the little devil horses!"

Bourke-White had heard a great deal about southern chain gangs: lines of prisoners, bound together at the ankles by iron chains, who were sent out on work crews. She wanted to photograph a chain gang at work; but when she and Caldwell passed one on a back road and stopped to take pictures, the captain in charge of the gang started waving a rifle at them, threatening to shoot out their tires. With the help of one of Caldwell's many acquaintances in southern politics, Bourke-White procured an official permit to photograph the chain gang. As they returned to the site, she waved the permit out the window like a truce flag, hoping the guard would not shoot her arm off. Eventually—after reading the permit aloud, because the captain was illiterate—Bourke-White got her pictures, some of the most impressive of the trip.

Some church services, Bourke-White learned, were almost as hard to photograph as chain gangs. She was determined to produce a photographic record of revival-type church meetings, where the emotional sermons sent parishioners into an ecstatic frenzy. But, although black revivalist churches welcomed visitors, their many all-white counterparts liked to keep themselves hidden. One Sunday, Bourke-White and Caldwell came upon a bleak, unpainted little church in a destitute South Carolina town. The all-white congregation had already assembled, locking the door behind them. Bourke-White tucked a small camera into her jacket, and Caldwell filled his pockets with flashbulbs. After climbing through

an unlocked window, Bourke-White started shooting as fast as she could, Caldwell changing her flashbulb with every shot. All around them, worshipers were in a state of religious fervor, while the minister seemed to have slipped into a trance. As the shouting died down and the minister began to revive, Bourke-White and Caldwell jumped back through the window and drove out of town.

After they had completed their southern travels, Bourke-White and Caldwell returned to New York to put their book together. While she supervised her darkroom staff, Caldwell completed his written text, which bitterly attacked the sharecropping system and called for its reform. Caldwell also thought of a title—*You Have Seen Their Faces*—and tried it out on his partner.

Bourke-White loved the title. It captured perfectly the spirit of what she had hoped to discover in her work down South: the actual faces of those who suffered poverty, loss, and need. As she wrote in her autobiography:

> Many times in sharecropper country, my thoughts went back to the Dakotas, where the farmers were stricken with the drought. Their very desperation had taught me that man is more than a figure to put into the background of a photograph for scale . . . and here with the sharecroppers, I was learning that to understand another human being you must first gain some insight into the conditions which made him what he is. The people and the forces which shape them: each holds the key to the other. These are relationships that can be studied and photographed.

You Have Seen Their Faces created a sensation. In the 1930s, before the invention of television, photographers had just begun to use their cameras to report on social issues. In this atmosphere, Bourke-White's dramatic, unsparing pictures provided many Americans with their first glimpse of the South's rural poor. Readers who looked into the pinched, lined, despairing faces in Bourke-White's photographs were forced to see the terrible effects of deprivation on the human body and spirit. The book, which became a best-seller, led to a new awareness of the evils of sharecropping, and inspired federal laws designed to help poor farmers.

You Have Seen Their Faces, in which photographs were emphasized as strongly as text, was a milestone in the history of photography. It belonged, as literary critic Malcolm Cowley observed, "to a whole new art, one that has to be judged by different standards."

During her childhood in New Jersey, Margaret White enjoyed taking nature walks with her sister and parents. The White home was filled with unusual pets, collected on these trips.

TWO

Snakes and Stockings

Margaret Bourke-White's parents were serious-minded people who firmly believed in bettering themselves through study and hard work. Joseph White and Minnie Bourke also shared a love of nature, and it was this love that first brought them together. They met in New York's Central Park in the late 1890s, on one of the early morning bird walks popular at that time. Because both attended night school—Joseph studying to earn an engineering degree, and Minnie taking courses in stenography and cooking—they had few chances to meet during the week. But on weekends, chaperoned by friends and relatives, they went on bicycle trips to the nearby Catskill Mountains. There they studied nature, read aloud to each other from the works of great philosophers, and fell in love.

Although bicycling was a national craze among young men at the turn of the century, many people considered it an improper pastime for a woman.

Minnie Bourke, who prided herself on her advanced ideas, scandalized her mother by riding a bicycle everywhere, even on Sundays. When Minnie took off on her bike, her full skirts hemmed to an indecent three inches above the ground, Isabella Bourke would shake her head sadly and say, "Minnie's going to the devil!"

Minnie Bourke often found herself at odds with her mother, an overworked, uneducated woman who resented Minnie's independent ideas. Isabella Bourke, first sent out to work as a cook in Ireland at age six or seven, had experienced many hardships in her life. In the 1860s she had married Joseph Bourke, a carpenter, and soon afterward they emigrated to New York. Joseph Bourke proved to be a drunken, unreliable husband. In 1883, when his daughter Minnie was 10 years old, he died in a fall from a skyscraper scaffold, leaving his wife with no money and a houseful of children. After his death, Isabella Bourke struggled to make ends

meet, working as a private nurse and midwife. She had little patience with Minnie's books, night classes, and great plans for the future.

But Minnie found a kindred soul in Joseph White. Like her, Joseph had great ambition—not for wealth or fame, but for fulfilling work, a cultured home, and a life lived according to high principles. And unlike many young men, Joseph White took Minnie's intellect and ideas seriously. He later told his daughter Margaret that what first attracted him to Minnie Bourke was her open, inquisitive mind.

During one of their nature rides through the Catskills, Minnie's bicycle broke down. They decided to walk together instead of riding, and climbed to the top of a mountain, taking with them the volume of Ralph Waldo Emerson they had been reading aloud to each other. On the mountaintop, Joseph proposed to Minnie and was accepted.

Joseph White's background was similar to Minnie Bourke's in many ways. He also came from a large family. His father, like her parents, had emigrated from Europe and, once in America, had struggled to earn enough money to make ends meet. But while the Bourkes were English and Irish Christians, the Whites were Orthodox Jews of Polish descent. Joseph's family strictly observed Orthodox religious customs while he was growing up. By

the time he met Minnie Bourke, however, he practiced neither Judaism nor any other religion. Along with several other members of his family—including his mother, whose sudden refusal to follow Orthodox dietary laws broke up her marriage of 29 years—Joseph White had become an ardent follower of the Ethical Culture movement.

Ethical Culture is a moral philosophy, not a religion. Its founder, Felix Adler, stressed the values of spiritual growth, hard work, and living an ethical life based on reason. Adler gave weekly lectures, which Joseph White attended faithfully. When he and Minnie Bourke became engaged, he brought her with him; soon afterward, they asked Adler to officiate at their wedding. Although Joseph and Minnie White raised their children as Christians, theirs was a Christianity deeply influenced by the values of the Ethical Culture movement. Her parents' strict moral and intellectual standards affected almost every aspect of Margaret Bourke-White's childhood.

Minnie Bourke and Joseph White were married in 1898. They settled briefly in the Bronx before moving to the small town of Bound Brook, New Jersey, near the factory where Joseph White worked as an engineer and inventor. The Whites continued their life of study and self-improvement, still reading to each other and taking courses whenever possible. Joseph be-

Though he spent more time thinking about his work than playing with his children, Joseph White had a profound influence on young Margaret.

was often frustrated by the narrow boundaries of her life.

Margaret Bourke White (she would use a hyphen to create a new name from her middle and last names some 20 years later, when starting out as a professional photographer) was born on June 14, 1904, the second of the Whites' 3 children. From a very early age she vowed to live a much broader life than her mother's. As a child, she planned to become a herpetologist—an expert on snakes. She recalls in her autobiography: "I knew I *had* to travel. I pictured myself as the scientist (or sometimes as the helpful wife of the scientist), going to the jungle, bringing back specimens for natural history museums and 'doing all the things that women never do,' I used to say to myself."

Margaret's parents never discouraged her grand ambitions. On the contrary, they took advantage of every opportunity to educate Margaret, Ruth, and their younger brother, Roger. Minnie White, who had a flair for teaching, put maps up on the walls, taught her daughters how to cook and sew, sent the children out to concerts and gym class, and filled the house with books. Joseph White took the children on nature walks through the lovely hills surrounding Bound Brook. At home, he helped the children in their study of wildlife, building cages for Ruth's turtles and the snakes and

came deeply engrossed in his work inventing new printing presses and techniques, but Minnie had a more difficult time finding an outlet for her great curiosity and mental energy. When the Whites' first child, Ruth, was born in 1901, Minnie White had little time left for her night-school education. For the rest of her life, she devoted most of her energy to her children, her home, and her husband's work, and

Margaret grew up in Bound Brook, a typical, small New Jersey town of its time. She spent some of her happiest times traveling with her father to similar towns.

insects Margaret brought home. Soon the house was filled with wildlife—caterpillars on the dining-room windowsill, turtles under the piano, a baby boa constrictor nesting in a warm blanket, even a tame puff adder who liked to curl up on Mrs. White's lap when she sat reading by the fireplace.

Her parents instilled in Margaret a love for challenge and adventure. As a very young child, Margaret seemed timid in some ways—afraid of the dark, squeamish around some animals, and terrified of being left alone. Her parents, who valued courage highly, decided to cure her of her fears, and set

about this task rationally and scientifically. Mrs. White devised little games. In one game, she would leave the house, going farther and remaining away longer each time, until Margaret felt comfortable staying home by herself. Mr. White would take Margaret on special outings, teaching her which snakes were poisonous and convincing her to pick up the nonpoisonous snakes and handle them without fear. These nature trips sparked Margaret's interest in herpetology, which lasted well into adulthood.

Joseph White was always fascinated by the photographic process and the

science of optics (the transmission and control of light), and constantly experimented with lenses, prisms, and camera devices, both at his job and at home. When he worked at home, he sometimes had the children help him with his experiments. More than 50 years later, his daughter Margaret recalled the thrill she felt when he "used us children as guinea pigs for trying out prisms and viewing lenses which created magic effects of depth illusion." She credited her father's "keen attention to what light could do" as a powerful influence on her own work.

Margaret's father was an enthusiastic amateur photographer. During her childhood, he took thousands of photographs of his family, his inventions, and the plant and animal life of Bound Brook. In her autobiography, Margaret claims that she "hardly touched a camera, and certainly never operated one" until after her father's death. But she did spend many hours tagging along when he took his pictures, and doing her best to assist him in the makeshift darkroom he set up in the bathroom. Margaret adored her mysterious, silent father. He was her hero, the great inventor and genius.

Margaret never felt happier than when her father took her on a business or photography trip. Once, when Mr. White and Margaret were traveling near Niagara Falls, he saw a group of poor French Canadian children beg-ging with their hands outstretched. He thought they would make a great photograph, but when the children saw his camera they started to run away. Margaret quickly fished a coin from her pocket and tossed it into the air. The children came scrambling back, and her father got the photograph he wanted. Even though Margaret may not have touched a camera, she already had a knack for setting up a dramatic picture.

Sometimes Mr. White took Margaret with him on trips to the factories where he helped install printing presses. When she was about eight, he took her to the foundry where the presses were made. Margaret climbed with him to a balcony in the factory and peered down into the darkness. Here is how she later recalled that day:

> "Wait," Father said, and then in a rush the blackness was broken by a sudden magic of flowing metal and flying sparks. I can hardly describe my joy. To me at that age, a foundry represented the beginning and end of all beauty. Later when I became a photographer ... this memory was so vivid and so alive that it shaped the whole course of my career.

For the rest of her life, Margaret loved the excitement of industry, the beauty present in the movement of powerful machines and the flow of molten metal. It was through her photographs of factories that she would first rise to national fame.

In his work, his photography, and his study of nature, Joseph White strove for perfection. Even when they were very young, he expected his children to work as hard as he did, and to set the same lofty standards for themselves. Minnie White too, even more of a perfectionist than her husband, continually encouraged her children to reject the easy way of doing things. Whenever Margaret, Ruth, or Roger took a school test where they could choose which questions to answer, Mrs. White would say: "I hope you chose the hardest ones!"

Mrs. White set severe rules for her children. The girls had to wear cotton stockings at all times, never the silk ones many of their classmates wore. Mrs. White did not permit her children to chew gum, play cards, eat white bread or fried foods, or read the funny papers. They could not even visit playmates' houses if their families read the funnies. Margaret's mother also disapproved of most films, and rarely if ever let her children go to the movies with their friends.

Reminiscing toward the end of her life, Margaret Bourke-White wrote that her parents' constant striving for perfection, and their love of truth, provided her with "perhaps the most valuable inheritance a child could receive." Even so, at times Margaret must have longed for a parent who would accept her as she was. Minnie White constantly criticized her children. Ruth, in particular, suffered deeply because she never seemed able to satisfy her mother. Throughout her childhood, Ruth wrote notes begging Mrs. White not to feel ashamed of her and not to scold her for being a "sloppy, nasty girl." Her mother never answered them. And Roger White later admitted that, in his mother's eyes, he never seemed to do anything right.

If Joseph White imposed somewhat fewer rules than his wife, it was because he left most of the details of home life to her. He was so caught up in his inventions, and so involved in the world of ideas, that he often seemed unaware of the real world around him. In the evening, he frequently sat silently in his chair for hours at a time, thinking. On Sundays he worked all day at his drawing board; his family seldom saw him before suppertime. For Margaret, her father's silence "dominated our whole household. Throughout my childhood, everything was geared so as not to disturb Father while he was 'thinking.'" Minnie White regarded it as her duty to respect her husband's silences, and to do everything she could to assist him in his work. She always made sure that a pad and pencil lay on his bedside table in case, as often happened, he might wake for a moment and want to scribble down some formula or design. But his silence made her unhappy. "If only Father would *talk* more," she used to com-

Like many others of his time, Joseph White was an avid amateur photographer. Margaret shared her father's interest, though she probably never touched a camera until his death, when she was 17 years old.

Minnie White reads to Margaret (left), Ruth (center), and Roger (right). Followers of the Ethical Culture movement, the Whites brought their daughters up according to a strict code of morality.

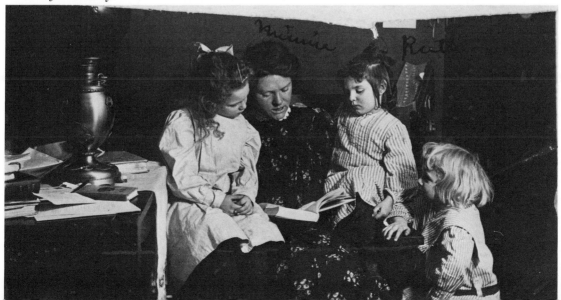

plain to Margaret. Like their mother, the White children must have wished that Mr. White would take more time to talk with them, play with them, *notice* them.

Of the three White children, Margaret apparently gained most and suffered least from her rigorous upbringing. Her remarkable mental curiosity, along with her interest in everything he did, endeared Margaret to her inventor father, probably making her his favorite. And her mother also found more to approve of, and less to criticize, in Margaret than in her other children. With her ready wit, adventurous spirit, and great store of energy, Margaret must have reminded Minnie White of her younger self.

The White children attended a four-room elementary school in Bound Brook, which went from grades one through eight. Margaret quickly made a name for herself in school. A bright student, she was determined to excel. She also seemed bent on attracting attention to herself. In one of her most dramatic attempts to get noticed, she walked to school with a puff adder twined around her arm.

In Plainfield High School, Margaret continued to do well academically, especially in English and biology. Articulate and outspoken, Margaret sometimes behaved outrageously—as when, once again, she caused an uproar by bringing one of her snakes to school. Margaret also got involved in

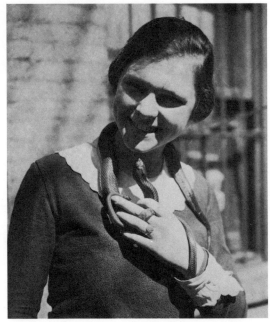

By the time she graduated from high school, Margaret had decided to become a herpetologist—an expert on snakes. She once arrived at school carrying a puff adder.

school activities: She edited the yearbook, acted in school plays, joined the debating society, and became president of the dramatic club. She loved language, written and spoken, and loved performing—on stage, at a debate podium, or in class—more than anything else.

Margaret's fellow students admired her for her intelligence and originality. They respected her dedication to excellence, and were impressed by what they saw as her self-confidence. In their eyes, Margaret had risen above caring about ordinary high-school

problems like dances, clothes, and dating.

But Margaret did care about these typical teenage concerns. She wanted more than the respect of her classmates: She wanted to *belong*, to feel like one of them. Though she might have found it exciting to stand out from the crowd, at times she would have traded all her successes for a more ordinary kind of popularity. Despite this longing, however, Margaret was never a member of her school's social elite.

Part of the problem was her clothes, which were practical, childish, and ugly. Her mother allowed no frivolous or tight-fitting dresses, or makeup. And, although Margaret would grow into a beautiful woman, she was not conventionally pretty when young: Her eyes seemed too piercing, her face too broad, her figure a bit too plump.

More than anything, Margaret wanted someone to invite her to a high-school dance. Her mother sent her to dancing lessons, assuring her that if she became a good dancer, she would soon find a partner. But, although Margaret always had many platonic friends among the boys—plenty of partners for canoe trips, picnics, and YMCA outings—nobody showed any romantic interest in her.

Margaret felt certain that all this would change when she won a school contest at the end of her sophomore year, an annual writing competition open to sophomores, juniors, and seniors. The prize—$15 worth of books, to be selected by the winner—would be presented just before the graduation dance. Margaret waited until the last minute to write her story, scribbling it down in the two hours before the contest deadline. She could hardly believe it when she learned that she had won the school's most prestigious writing award.

When the day came to step up on stage and accept her prize—she had chosen the definitive books on moths, frogs, and reptiles—Margaret felt convinced that her moment had come, that winning the school prize meant she would no longer have to wait in the wings while her classmates were dancing. Holding her heavy stack of books at the celebration that followed, Margaret waited expectantly while the dancing began. But as the dance floor began to fill, her heart began to sink.

No boy came forward that night, or any other night during her high-school years. Margaret was bitterly disappointed. When drafting her autobiography nearly half a century later, she wondered whether the boys had been put off by "the Spartan aura" of her upbringing, and whether things might have been different if her parents had allowed her to wear silk stockings.

White transferred to the University of Michigan at Ann Arbor to pursue her interest in herpetology but found herself devoting more time to photography.

THREE

"Nothing Would Be So Hard Again"

In September of 1921—after a summer at Rutgers University, where she had taken swimming classes and still more dance lessons—Margaret White enrolled as a freshman at Columbia University in New York City. It was a heady time. At 17, she was living on her own in the world's biggest city, with the prospect of 4 years at its most prestigious university before her. In the larger world of college, she finally achieved the popularity that had eluded her during childhood. She made friends far more easily than she had in high school, and would soon discover that college men were more than willing to ask her out on dates.

White was home for Christmas when her father suffered a massive stroke at the age of 51. He died less than 24 hours later. Although he had suffered a stroke seven years earlier, everyone believed he had fully recovered, so his death was entirely unexpected. The loss of Mr. White came as a terrible blow to his younger daughter, and he remained an almost godlike figure to her, probably the chief inspiration of her life and work. Almost immediately after he died, she took up his favorite pastime, photography, as her own.

The White family soon discovered that Mr. White's death had left them with almost no resources. During his lifetime the family had always lived comfortably, if not opulently, thanks to his steady salary. But after his death, White quickly learned about financial insecurity. Resourceful as always, she began taking various part-time jobs to help pay for school

With some help from her father's brother, White returned to Columbia for her second semester. There, as part of an art course, she studied photography with Clarence White, a renowned photographer and an inspiring teacher. Clarence White was a leader of the pictorial school of photography, a group which sought to secure the place of photography among the arts, rather than considering it as a simple mechanical technique. Pictorial school photographers

At Columbia University, White studied photography under Clarence White, a proponent of the pictorial school of photography. Pictorialists hoped to establish photography as a true art form.

designed their works to look like paintings, using a blurry, soft-focus style as one method of achieving this goal. Margaret White's early photographs followed this tradition; some of them look more like watercolor paintings than like the crisp, extraordinarily detailed photos she produced at the height of her fame.

Hearing of her daughter's interest in photography, Minnie White somehow saved $20 and bought a secondhand camera for her. It had a crack across the lens, but it was a serious, professional camera. And, given White's

blurry, misty style at the time, the crack hardly mattered.

That summer, White got a job as the photography and nature counselor at a camp in Connecticut. She also set up her first photography business, selling postcards of the area and portraits of the campers to parents and tourists. As she would for the rest of her professional life, White worked tirelessly on both the artistic and the commercial aspects of her photography, staying up all night to get just the right print or to meet a customer's demands. And if getting the perfect van-

tage point meant hanging over a cliff, she never hesitated to take the risk. In this, also, the young camp counselor foreshadowed the mature Bourke-White, who would become as famous for her daring as for her skill.

White's photos sold well, and she felt proud to have made some money. But she could not hope to earn enough to pay for her tuition at Columbia. It came as a complete surprise when some friends of the White family offered to pay her way through at least one more year of college. Having heard about the young student's talent and her plight, they gave her money for tuition, books, and even clothes. For the rest of her life, White remembered her benefactors with grateful affection; 15 years later, she dedicated a book to one of them.

Because herpetology was still White's main academic interest, she transferred to the University of Michigan in Ann Arbor for her sophomore year, to study with Alexander Ruthven, an eminent zoologist. A serious student, White received excellent grades in the subjects she liked best. She also began spending more time taking photographs. For the school yearbook, she took a series of bold and innovative

Moving to New York to attend college, White discovered the excitement of life in the city. Urban architecture served as the subject for many of the pictures she took there.

studies of school buildings, often draping her lens with a thin cloth that made her images of the buildings look like abstract shapes. She climbed across steep roofs and down into dark tunnels to take pictures, thrilled by the adventure.

White had no intention of getting seriously involved with anyone at this stage of her life, but one winter morning she met Everett Chapman, and all her careful plans soon changed drastically. In her autobiography she describes their first encounter:

> We met in a revolving door. I was on my way into the cafeteria on the University of Michigan campus, and he was on his way out, and he kept the door turning around with me in it until I had made a date with him. From that minute on we fell in love so fast that there was hardly time to breathe.

Chappie, as everyone called him, a tall, startlingly handsome graduate student in electrical engineering, seemed like the ideal man to young White. When he conducted experiments in his lab, she could see that he was dedicated and single-minded—a man of vision whose work was "more than a method, it was a faith." In this he reminded her of the father she had just lost. He even did the same kind of work: engineering for industry. Yet, where Joseph White had remained silent and serious at all times, Chappie had a fun-loving, whimsical side. He loved jokes and dances and nightlife, and worked his way through school by playing drums in a dance band. To White, it was a thrilling combination— and, to top it off, Chappie was a photographer.

White spent one summer as a camp counselor, making some extra money on the side by photographing the campers and their surroundings.

At the University of Michigan, White met and married Everett Chapman, despite her plans to avoid serious relationships.

White and Chapman moved to Cleveland in 1925. There, White enrolled at Case Western Reserve University and took a job at the Natural History Museum.

In the months that followed, White and Chapman spent a great deal of time together—dancing, going to the movies, and talking about the futures each of them had planned. Cameras in hand, they roamed the countryside around the university, taking pictures and walking in the moonlight. They found that they liked the same books and, just as Margaret's parents had done, they discovered the joys of reading aloud to each other. That spring, Chapman told White that he wanted to spend the rest of his life with her.

White, too, was passionately in love, but she felt torn; everything had happened too quickly, and her life and emotions seemed out of control. That summer she took another job as camp counselor, and made plans to produce a book of insect photographs—but for

the first time in her life, she began to have bouts of insomnia, nightmares, and exhaustion. Thinking about Chapman made her happy, but at the same time it made her miserable. She wondered what would become of her plans to travel, study nature, perhaps even become a great photographer, if she married him. But she thought that if she chose to pursue her professional goals she might be lonely the rest of her life. In the meantime Chapman had already become fiercely jealous—not just of other men, but of her time, and even of her thoughts.

During White's second year at Michigan, she and Chapman again took photos for the school yearbook. They even sold some of their work—to school newspapers, and at a show they arranged. But at the same time,

their personal relationship grew more stormy. He raged that she did not pay enough attention to him; she worried about being swallowed up. Neither Chapman nor White believed in sex before marriage, and sexual frustration might have added to the tension between them. That winter, despite their conflicts, they decided not to wait any longer; they would get married at the end of the school year.

The marriage, a disaster from the start, was heralded by one bad omen after another. On the night before the wedding, Chapman, who had made White's ring himself, brought her down to his welding lab to give the ring a final touch. But when he tapped the wedding ring, it broke in two. The wedding itself—held on Friday, the 13th of June 1924, a day before the bride's 20th birthday—was a dismal affair in a registry office. The groom's mother cried throughout the ceremony, for she bitterly opposed the marriage.

To stay close to Chapman's labs and the university's darkrooms, the newlyweds honeymooned at his parents' lakeside cottage just 17 miles from Ann Arbor. A few days into the honeymoon, Chapman's mother arrived at the cottage, leaving her own husband at home. It soon became clear that Mrs. Chapman planned to stay at the cottage for some time.

One afternoon at the cottage, while Chapman was in Ann Arbor and White stood ironing his shirts, her mother-in-law made her feelings about the marriage even more explicit. Years later, Bourke-White recalled the incident in her autobiography:

> "Well, Margaret," my mother-in-law's rich contralto sounded from the next room, "how did your mother feel when she heard you were going to be married?"
>
> I tried to answer, knowing how different would be the point of view of the two mothers. "Mother was very concerned at first because she wanted us to finish school, and because she thought we were both so young. But when she saw Chappie and me together, she was glad."
>
> "She's gained a son and I've lost a son. . . . You got him away from me. I congratulate you. I never want to see you again."

Terrified, White fled the house and walked the entire 17 miles to the university.

A few months after the wedding the couple moved to Indiana, where Chapman had gotten a teaching job at Purdue University. Although White enrolled as a student, it was a horribly lonely time for her. Her marriage cut her off from her fellow students, while her youth made it difficult to make friends with other faculty wives.

In marriage, as in everything else, White felt driven to succeed. She did her best to play the role of a traditional wife, but somehow Chapman was never satisfied. On rare days, she and her husband would remember how happy they had once been; but more

often, they fought. And Chapman's mother continued to interfere, writing that her son had betrayed her by getting married, and that he should come back to his "real" family, where he belonged.

In 1925 the couple moved to Cleveland, where Chapman had a new job. White signed up to take night classes at yet another college: Case Western Reserve. By day, she worked as a teacher in the Natural History Museum, an unusual sign of independence at that time, when few wives worked outside the home if their husbands had good jobs. But White wanted to make sure that she could support herself—perhaps she already knew that her marriage would not last.

The unhappy couple stayed together for two years that marked the low point of White's life. When the end of her marriage finally came, Bourke-White later wrote, she made "a discovery. I had been through the loneliness and the anguish. I had lived through the valley of the shadow. It was as though everything that could be really hard in my life had been packed into those two short years, and nothing would be so hard again."

Preferring to get on with her life, White wasted little time blaming herself or Chapman for the failure of their marriage. She even managed to see her jealous, resentful mother-in-law as a positive influence. "I owe a peculiar debt to my mother-in-law," she wrote. "She left me strong, knowing that I could deal with a difficult experience, learning from it, and leaving it behind without bitterness, in a neat closed room." White came to believe that "this beautiful rather tragic woman was the greatest single influence on my life. I am grateful to her because, all unknowing, she opened the door to a more spacious life than I could ever have dreamed."

While struggling to save her marriage, White had often lost sight of her own ambitions. But after her marriage, spurred by the memory of her mother-in-law, they returned with greater force than ever before. She determined to get her college degree and then—as a naturalist, or a photographer, or both—make her mark on the world. And she decided to do it on her own. Never again would she allow herself to need another person the way she had loved and needed Everett Chapman.

While attending Cornell University, Margaret White made an early foray into the field of commercial photography, shooting and selling pictures of the college campus.

FOUR

The Promised Land

Margaret White still needed a full year's study before she would receive her college degree. She had already attended five different universities. In 1926, she enrolled at a sixth: Cornell University in Ithaca, New York. She later claimed that she had chosen Cornell because she had read about the waterfalls on campus. Perhaps she also wanted to live far from Cleveland and Chapman.

White had hoped that at Cornell, where she kept her marriage and its failure a secret, she might enjoy the same easy popularity and sense of belonging of her earliest college years. This never happened. Still smarting from her experience with Chapman, she became shy and had trouble making new friends. But, though her personal life at Cornell fell short of her high expectations, she often found her work there exhilarating. Although still interested in herpetology—so much that she applied for a postgraduate job working with snakes at New York's

American Museum of Natural History—White had become more and more hopeful that photography would be, as she later called it, her "trade and deep joy." As she had done at Michigan, White began taking pictures of the school buildings and grounds, and was soon earning a regular stipend from the *Cornell Alumni News* for cover photos.

She also organized a small business selling her campus scenes to fellow students. Sales were brisk. At Christmastime, she set up a booth in her dorm and enlisted some 20 fraternity men to peddle her photographs on other parts of the campus. Unfortunately, she never stopped to think that the demand for these pictures might be seasonal. Sales fell off dramatically after the Christmas rush, leaving her with no money and a huge pile of expensive unsold prints. This experience, she later recalled, "nearly prejudiced me against photography forever."

Her year at Cornell provided the first signs that White had developed a talent not only for photography, but also for attracting people who could help her with the technical and marketing aspects of her work. From the earliest stages of her career, the people who knew her had believed in her. They admired her courage and pluck—the way she would go anywhere to get a picture, then work for days to perfect it and days more trying to sell it. Time after time, those around White— friends, darkroom owners, editors, technicians, business people—got caught up in her enthusiasm, becoming her willing helpers. Her marital problems may have left her shy and confused in many social situations, but she soon learned to make use of her personal charisma whenever it might further her career.

Most of all, of course, people were impressed with the photographs themselves. Even at Cornell, when she was still copying the techniques of Clarence White and had not yet formed her own distinctive style, several architects, struck by the power of her *Alumni News* photos, wrote to encourage her to become an architectural photographer after graduation.

White felt surprised and thrilled at what she called "the growing feeling of rightness I had with a camera in my hands." The prospect of becoming a full-time photographer opened "dazzling new vistas." But she wondered if she, an inexperienced young student and a woman besides, could expect any success in the tough, mostly male world of professional photography. Concerned that the architects who had encouraged her might have been swayed by their sentiments as Cornell alumni, she decided to seek an unbiased opinion of her work. Near the end of the school year, she brought a portfolio of her architectural photographs to a prominent New York architect, whose name a friend had given her. Arriving at his firm unannounced, she found the architect, Benjamin Moscowitz, on his way out the door, hurrying to catch his commuter train. She quickly outlined her problem to him, but Moscowitz looked at her blankly and edged toward the elevator.

For the rest of her life, Bourke-White maintained that had the elevator arrived immediately, she would have lost heart and gone to work at the Museum of Natural History. Fortunately, she had time to recover her poise and open her portfolio. As soon as Moscowitz saw the pictures, he forgot about his train. He led her into his office and called in some of his colleagues to examine her work—views of Cornell, some blurry and some in the more sharply focused style she was just learning. The architects admired them all, assuring her that she could take her portfolio to any architect in the

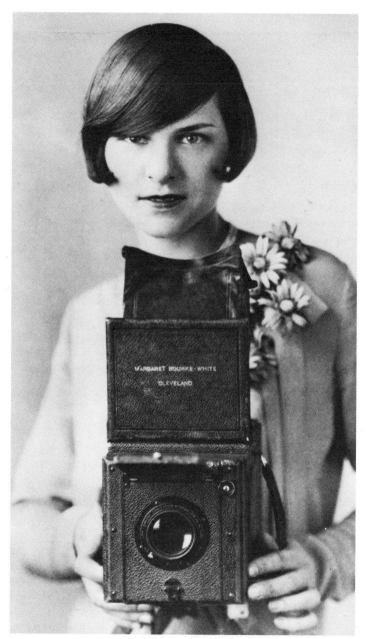

As she set out to start her career in Cleveland, Bourke-White had her newly adopted professional name embossed on her camera and then posed for this publicity still.

country and find work. It was, she later recalled, "the kind of golden hour one remembers for a lifetime. . . . Everything was touched with magic now."

White decided that upon graduation, she would set up her own photography studio. For a number of good reasons, she chose Cleveland as its site. Cleveland was a big enough city for her to find clients, but not so huge that she might get lost in the crowd. She knew the town—her most recent home before Ithaca—well. And Cleveland had become a bustling city of factories and commerce—the perfect place to begin her experiments in industrial photography.

After her graduation in 1927, White took the Great Lakes night boat to Cleveland. As she stood on deck the next morning, gazing at the Cleveland skyline through the morning mist, she felt as if she were coming into the promised land.

Perhaps, as she stood on the deck, White also entertained hopes of reviving her marriage. Chapman, still her legal husband, lived in Cleveland. For a brief period after her return, the couple did try living together, but almost immediately realized, once again, that they would never get along as husband and wife. One quiet Saturday morning, White went to the courthouse and obtained her divorce, resuming her full maiden name of Margaret Bourke-White (with the addition of a hyphen).

She and Chapman remained friends and sometimes made a joke out of pretending that they hardly knew each other when people were around.

Bourke-White's favorite part of Cleveland was its sprawling, swampy industrial backyard, known as the Flats. The Flats might have seemed hideous to most people's eyes, but to Bourke-White they were a photographer's paradise. She marveled at the high bridges overhead, the girders and cranes, the rushing traffic, and the huge smokestacks, which rose up from the blast furnaces in the steel mills. Bourke-White soon made up her mind to find a way to get inside those "slab-sided, coffin black" mills and capture their strange beauty. She had no idea how she would manage it, because women were prohibited from entering the Cleveland mills, but Bourke-White was determined to break down that barrier someday. Until that time, she hoped to earn enough money from architectural assignments to pay for the experimental photographs she hoped to take inside the mills.

Despite what she had been told by the architects who had seen her work at Cornell, Bourke-White did not find clients easily. All day, every day, she made the rounds with her portfolio, looking for work. By nightfall the high heels on her only good shoes would be worn down, and she would take them to be recapped at a local shoeshine

parlor. While she waited, barefoot, she made notations for her file. She made up a new card for every prospective client she had seen, and was careful to note whether she had worn her blue hat and gloves, or her red ones, with her only suit. It would not do for an architect or landscape designer to think that the proprietor of the Bourke-White Studio could afford only one outfit.

At the time, the Bourke-White Studio was actually no more than a letterhead and some developing trays. Bourke-White made her prints in the kitchenette sink, rinsing them in the bathtub. Her "reception room," as she liked to call it, doubled as the room where she lived and slept—on a foldaway bed.

Some young architects, also Cornell alumni, offered the Bourke-White Studio its first paying job: an assignment to photograph a new school. If successful, the photographs would appear in a national architecture magazine. Although overjoyed at the assignment, Bourke-White worried a little when she heard that the magazine had already rejected several other photos of the same building. When she went to see the school for the first time, she saw why: Although the building itself had good lines, it sat in the middle of a littered, muddy wasteland. She originally planned to photograph the school against the sunset, in silhouette, but when she attempted this, she found that the sun set on the wrong side of the school. She decided to try a sunrise instead. After four days of getting up before dawn, she finally got a clear sunrise, only to discover that piles of trash blotted out her best angles. Finally she hit on the idea of creating her own landscaping. At a nearby florist she bought several bouquets of asters and planted them in the ground at strategic spots around the school. Then she placed her heavy camera low and shot up through the flowers.

The architects were amazed at the result—it looked as if the school stood in a field of asters. When the photographs were published, as Bourke-White later recalled, it "brought more work and a touch of prestige to the Bourke-White Studio." In the months that followed she received contracts to photograph office buildings, landscapes, and houses for architects and owners. Her jobs often seemed 10 times harder than they would have been for a more experienced photographer, or for one who had received more formal training. Although her eye and her inventiveness were already extraordinary, Bourke-White knew very little about the technical aspects of photography—the nuts and bolts of camera equipment, lighting, and processing. She had to learn on the job, by trial and error. Sometimes the errors were disastrous: One day, for example,

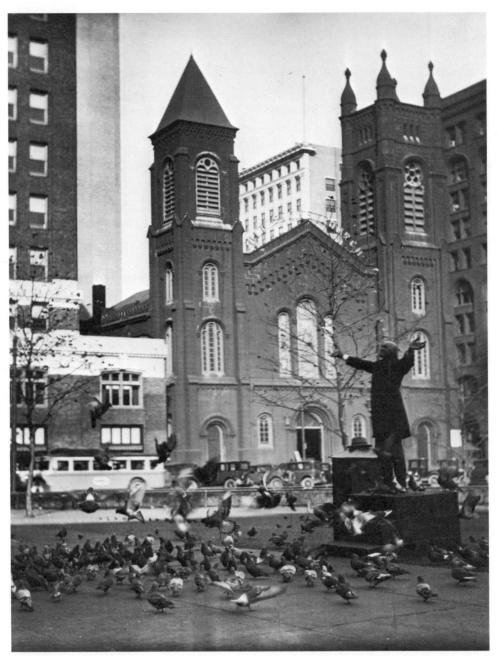

Displaying the persistence and resourcefulness that would mark the rest of her career, Bourke-White borrowed a camera and fed some pigeons to get this shot of a solitary orator.

unaware that her kitchenette was not lighttight, she ruined a whole day's work. Her assignment had been to photograph a flower garden, and when she returned to reshoot it, she found that a storm had destroyed all the flowers. From that day on, unless she had access to a real darkroom, she always did her developing and printing after sunset.

One windy morning, while crossing a square in downtown Cleveland, Bourke-White came upon an elderly preacher standing on a soapbox with his arms outstretched. His only audience was a flock of pigeons. Because she had been out interviewing possible clients, Bourke-White had no camera with her. Desperate not to lose this wonderful picture, she ran to the nearest camera store, where she quickly explained the situation, begging to rent or borrow a camera. The store clerk, sympathetic to her predicament, lent her a large Graflex. Stopping only to buy a bag of peanuts, Bourke-White hurried back to the square and got her picture, enlisting the aid of some friendly passersby who tossed the peanuts to keep the preacher's "audience" in place.

The picture made the cover of a local magazine. But much more important to Bourke-White's future career was her meeting with the kindly store clerk, Alfred Hall Bemis. Quite taken with the passionate young photogra-

pher who had borrowed his camera, Bemis became her mentor and valued friend. Throughout Bourke-White's time in Cleveland, Bemis lent her equipment from his store, helped her process her photographs, and provided her with much-needed technical pointers. He also offered a piece of advice she remembered all her life. "Don't worry about what the other fellow is doing," he told her. "Shoot off your own guns."

Soon after she meet Bemis, Bourke-White won her first industrial contract: Every month, the Union Trust Bank chose one of her industrial photos—a bridge, a factory, a smokestack—to use on the cover of its magazine. The bank paid her $50 a month for her cover photos—at the time, more money than she had ever dreamed of making from a single assignment. With part of her Union Trust earnings, she made a down payment on a battered old Chevrolet, which she nicknamed Patrick, and bought herself some new clothes.

Bemis and Earl Lieter, a photofinisher in his store, saw Bourke-White through many near disasters during her studio's early days. In her autobiography, she fondly remembers how they helped her cope with an assignment to photograph a prize bull in the lobby of a bank. For interior shots like these, Bourke-White needed to set off charges of flash powder, a task that she had no idea how to accomplish. With

Lieter's help, she finally managed to take a passable picture, but only after "billows of grey smoke rolled through the bank" and "ashes showered down on the shoulders of the depositors." The bank liked the photo enough to order 485 copies, which it wanted the next day; Bourke-White happily agreed. But when she told Bemis what she had undertaken to do, he was aghast—in those days, not even the largest commercial studios could produce 485 prints in 24 hours. The two of them would have to do everything by hand, because automatic printing, rinsing, and drying machines had not yet been invented. By working all night and borrowing every tray and fan and squeegee board in Bemis's store, she and her new friends got the job done.

With the profits from this sale, Bourke-White had saved enough money to buy a lens she thought "worthy of any steel mill." The morning after she delivered her 485 prints, she drove Patrick to the Otis Steel Company and sat looking at its brooding smokestacks, asking herself how she would manage to "get into that magic place."

Several weeks later, it occurred to her that the best tactic would be to go straight to the top. Armed with her portfolio and a letter of introduction from a wealthy client, she went to the office of Elroy Kulas, president of Otis Steel. Although Kulas was impressed by her intensity and liked the pictures she had taken of flower gardens and other "artistic" scenes, he wondered how she would find anything artistic in a steel mill. Bourke-White tried to explain that industry had a power and vitality that made it "a magnificent subject for photography," and that Kulas's steel mill reflected the booming, hopeful age in which they lived. Bourke-White saw industrial forms, with their clean lines, as "all the more beautiful because they were never designed to be beautiful." They were beautiful because they had a purpose.

Impressed by this argument, Kulas agreed to let Bourke-White try to find what beauty she could at Otis Steel. He instructed his staff to permit her to enter the plant whenever she wanted. Then, to Bourke-White's great relief, Kulas sailed to Europe for five months, never suspecting that she would spend almost every night in the mills while he was away.

It was 1928, and Bourke-White was 24 years old. By day, she earned just enough money to pay for the equipment she needed for her steel-mill photography. By night, she and Bemis prowled the catwalks of the dark mills. Bemis, reminiscing later with Bourke-White, recalled their first night in the mills this way: "We were standing up high someplace and they pulled a furnace, and you were as delighted as a kid with a Fourth of July firecracker...

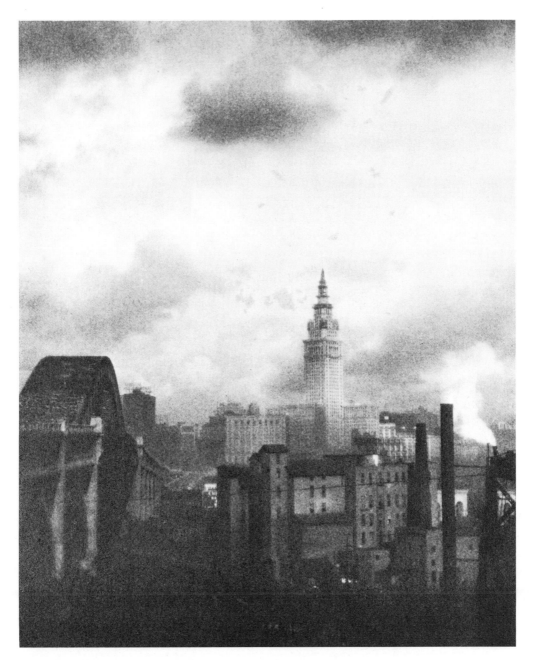

This 1929 photo of Cleveland's Terminal Tower, like much of Bourke-White's early architectural photography, reflects the influence of Clarence White, a chief proponent of the pictorial school.

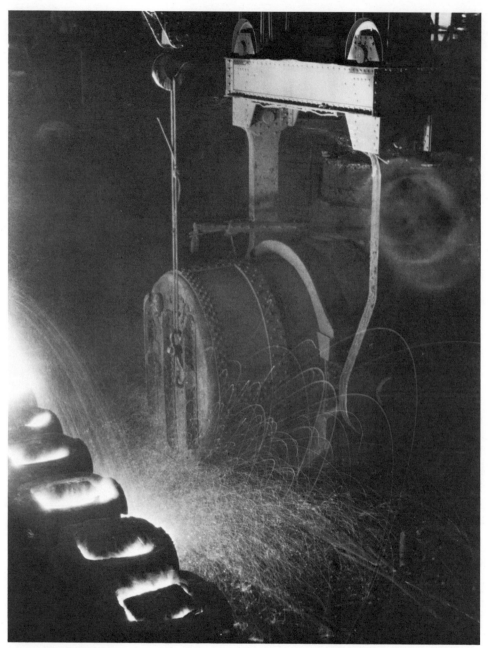

Bourke-White's work inside the steel mills of Cleveland launched her on the course to fame and represented a major breakthrough in modern photography.

You grabbed your camera and were off to a flying start... You had on some kind of flimsy skirt and high-heeled slippers. And there you were dancing on the edge of the fiery crater in your velvet slippers, taking pictures like blazes and singing for joy."

Bourke-White's joy was short-lived. None of her first pictures came out: She had mistaken the red, fiery heat of the mills for recordable light, but the darkness had left her film virtually blank. This was only the first of many technical problems that the dark mills would pose. Every night, Bourke-White and Bemis would experiment with a different piece of equipment from the camera store. They spent weeks trying out different floodlights, cables, and flash powders, but nothing yet invented seemed to provide enough light. Finally a traveling salesman came to town, carrying a sample case filled with 12 immense magnesium flares he claimed could "light up a hole in Hades." Bourke-White and Bemis convinced the salesman to use up 11 of his flares inside the mills. In a dramatic photo session, with the enormous flares exploding like Roman candles, Bourke-White photographed the liquid steel bubbling in its ladles and the orange smoke rising from the molten metal.

The negatives from this session exceeded Bourke-White's hopes. In one negative, she had actually reproduced the path of sparks—an astonishing feat at the time. But when she and Bemis tried to print the negatives, they discovered that no photographic paper on the market could capture this unique combination of very dark and very bright patterns.

Then Bemis met another traveling salesman, this one touting a new, ultrasensitive paper. On this new paper, with its thick deposits of silver emulsion, Bourke-White finally printed the pictures she wanted. By this time, Kulas had returned from Europe. Bourke-White greeted him with her 12 best prints.

Kulas was astonished. He had never seen anything like Bourke-White's steel-mill pictures, which seemed to capture perfectly the spirit of the mill. His company bought eight of the pictures, commissioned eight more, and printed them all in a booklet called *The Story of Steel*. Within months, they had appeared in magazines all over the Midwest.

That spring, Bourke-White received a telegram. Henry Luce, the publisher of *Time* magazine, had just seen her steel-mill photos and wrote that he wanted her to "come to New York within a week at our expense." Two days later she bought a ticket to New York City, where Luce would offer her a job that eventually made her one of the most celebrated photographers in the world.

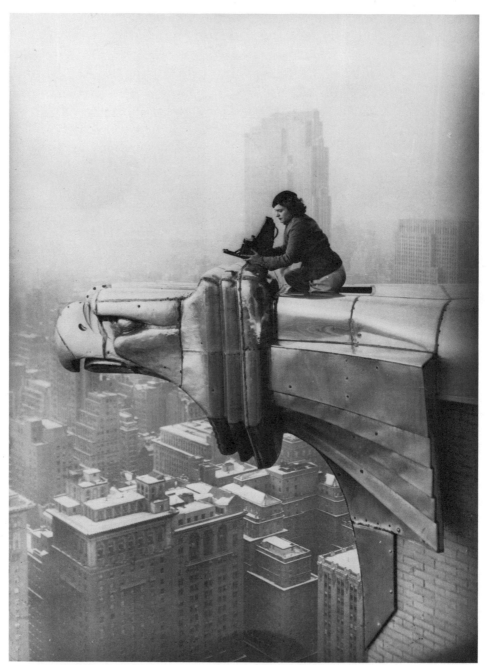

Always fond of heights, Bourke-White enhanced her reputation as a skilled and daring photographer by climbing onto the gargoyles outside her studio in the Chrysler Building to shoot the city far below.

FIVE

Fame and Fortune

Henry Luce planned to launch a new magazine about business and industry. As he told Bourke-White when she met with him in New York, he wanted it illustrated with the most dramatic pictures of industry ever taken. He wanted his magazine to provide a total picture of the modern industrial world. And he wanted photographs that would play an integral part in every story, not just randomly chosen illustrations. After he presented his idea, Luce asked Bourke-White for her opinion.

Bourke-White told him it was probably the best idea she had ever heard—it was as if Luce had spoken her own thoughts. With her work at the steel mills, Bourke-White had been one of the first photographers, perhaps the very first, to see photographs as a way of capturing the spirit of an age. Like Luce, Bourke-White believed that images of industry could best reveal the spirit of the 1920s. She also had a deep conviction that photography and writing could complement each other in telling a story. The magazine Luce

described—it had no name as yet, but would soon be known as *Fortune*—seemed tailor-made for her. She agreed to begin work almost at once.

After returning to Cleveland, Bourke-White wrote to her mother: "I feel as if the world has been opened up and I hold all the keys." Two months later, in July of 1929, she left for New York. From then until the mid-1930s, she divided her time between her work as a photographer and associate editor for *Fortune* and the free-lance work, mostly advertising photography, that she did in her new Manhattan studio.

In the eight months before *Fortune* hit the stands, Bourke-White and her fellow staffers began putting together a backlog of feature articles. *Fortune*'s editors quickly developed a novel approach to journalism: On each story, a writer and a photographer, sent to work as a team, were instructed to explore every aspect of a particular industry. Bourke-White's first assignment was a story on the shoemaking trade in Lynn, Massachusetts. She was delighted to discover that her partner

on the trip, veteran reporter Manfred Gottfreid, danced as well as he wrote. As she later remembered, "we danced our way to Boston on the night boat, and it was a lovely way to embark on a new life with a new magazine."

The stock market crash of 1929 began while Bourke-White was shooting an advertisement inside a Boston bank. She ignored the event, however, and missed a rare opportunity to record history in the making.

On her next assignment—glassblowing, then a dying craft—Bourke-White felt privileged to see and record a glassmaker, who made electric light bulbs with "the power of his lungs and the skill of his lips," blowing "golden-hot glass nuggets into huge bulbs, street-light size." In the months that followed, she photographed orchid growers in New Jersey, fisheries in Connecticut, and watchmakers at the Elgin Watch Factory. She loved all of it: the tiny watch parts, the baby orchids in their test tubes, even the mountains of slippery fish she had to climb to get her fishery shots.

Three months before the first issue of *Fortune* came out an event took place that forced its stockholders to consider backing out: the crash of 1929. In a matter of days, the bottom fell out of the stock market and the nation began its plunge into the Great Depression. When the crash began, Bourke-White was on assignment in Boston, photographing the new lobby of the First National Bank. Since her arrival in Boston, Bourke-White had been preoccupied with her work—and with the latest of her many boyfriends. Because he had promised to take her to a football game, she had been reading a book on the sport, not the newspapers, and had no hint of the impending disaster.

Hoping to find the bank free of distractions and interruptions, Bourke-White decided to work long past normal business hours. To her surprise and annoyance, she noticed that instead of going home, the bank officers spent the evening running back and forth across the lobby, dashing in front of her camera as if they had failed to see her. Eventually a bank executive stopped just long enough to ask: "Haven't you read the papers? They're

In the months preceding the publication of the first issue of Fortune, *Bourke-White traveled around the country documenting all types of American enterprise, including the Chicago stockyards.*

carrying everything away in a basket." Having no idea what he meant, she calmly resumed her architectural photography, while her assistant continued to shoo away any officials who blocked her lens.

When hearing of this incident years later, a friend pointed out that Bourke-White might have been the only photographer who managed to find herself inside a bank that night. Bourke-White regretted the missed opportunity: "History was pushing her face into the camera and here was I, pushing my lens the other way." It was a mistake she resolved never to repeat. Over the next few years, as the depression deepened and Bourke-White traveled across America and the world, she began to look beyond her own personal concerns and to think in terms of history. And, once she started looking for it, she had an almost uncanny ability to discover news, and history, in the making.

Though the American economy was collapsing all around them, *Fortune*'s stockholders decided to go ahead with the magazine. They believed—correctly, as it turned out—that enough wealthy advertisers and readers had survived the crash to provide a market for their expensive, beautifully printed magazine, which they had never intended for a mass audience.

For the lead story in its first issue, the editors knew they wanted Bourke-

White as the photographer, teamed with Parker Lloyd-Smith, *Fortune*'s managing editor. Finding the right topic posed more of a challenge. The editors wanted to choose an industry central to the American economy, but one that, as Bourke-White later said, would be a photographic "eye-stopper—an industry where no one would dream of finding 'art.'"

After a great deal of debate, the editors made their final choice: hogs. Bourke-White loved the idea—surely few readers could imagine any beauty in the vast and filthy Chicago stockyards, where 20,000 pigs were slaughtered every day. But Bourke-White did find beauty of a sort. She likened the Swift meat-packing plant to the *Inferno*, Dante's epic poem about hell, claiming that the "solemn procession" of hogs going to their death presented a kind of grim magnificence. The photographs she took for *Fortune*—the dark outlines of hog bodies passing through flames and knives on the assembly line—reflected her sense that even hog butchery had a grandeur of its own. (The smell, however, did not provide her with the same sense of grandeur. After Bourke-White had finished photographing the enormous mounds of pig dust sold to farmers as cattle feed, she left her camera cloths and light cords to be burned.)

Fortune's first issue was indeed an "eye-stopper," and the magazine soon

Bourke-White rose to prominence as a creator of precise images—such as this photograph of plow blades—that captured the spirit of the industrial age.

became the foremost journal of big business in America. With its gorgeous printing and brilliant staff photographers, it also gained recognition as the country's leading photography magazine. Its readership, though never huge, wielded enormous influence: millionaires and business leaders on the one hand, and photographers and photography patrons on the other. Bourke-White quickly became *Fortune*'s acknowledged star. Most issues contained at least one Bourke-White spread, and several featured more than one.

Before long, people began speaking of the Bourke-White style: her precision, her sense of form and pattern,

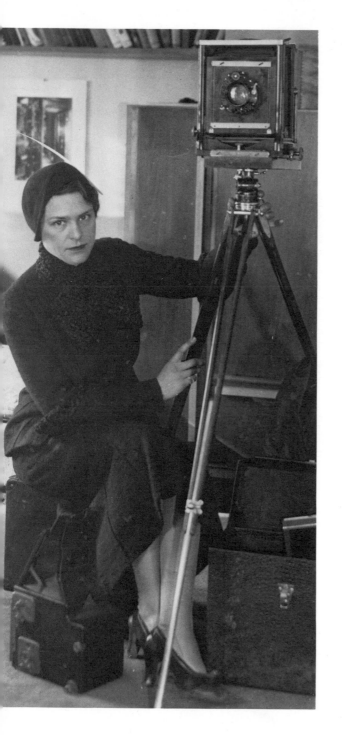

and especially her eye for movement and dramatic contrast. Unlike many young news photographers, Bourke-White rejected the small, hand-held cameras then being perfected. These smaller cameras might provide a sense of spontaneity—the feeling that an invisible observer was catching a chance moment—but Bourke-White preferred the sharper, more detailed images she could produce with large cameras and tripods. To achieve these effects, she often needed to work with a carload of lighting equipment and a team of assistants. She often spent a whole day, and several hundred feet of film, to produce a single print. Joseph White would have been proud to see that his daughter had inherited his streak of perfectionism.

Fortune did not hesitate to publicize Bourke-White as well as her photographs. To *Fortune* and the press in general, the glamorous young prodigy and her many daring exploits provided at least as good a story as, say, the logging industry. By the time she was 30, Bourke-White had become a media celebrity, the subject of newspaper articles and radio dramas. Advertisers paid her to endorse their products,

Bourke-White poses with her camera. The ambitious young photographer solicited advertising work at the same time that she filled a staff position at Fortune *magazine.*

and the press began building a legend around her.

Bourke-White willingly collaborated in the creation of the Bourke-White legend. From her earliest days in Cleveland, she had learned to project an image of herself as a means of marketing her work; for the rest of her professional life, she promoted and built upon this image. Of course, most of the news stories about her, and most of her own stories about herself, were true. She did race around the country, dangle from skyscraper girders and, often, dance or work all night long. As the legend maintained, she was totally dedicated and utterly fearless, and she was unquestionably a splendid photographer. But Bourke-White also chose to alter or omit a few facts about her life. For example, she carefully avoided any mention of her marriage to Chapman—and of her Jewish ancestry.

Bourke-White had not even known that her father was Jewish until after his death. Mr. White had hidden his religious background, probably because he feared that he and his family might fall victim to the anti-Semitism then rampant in America. Once she discovered the truth, Bourke-White did not mention her Jewish heritage—perhaps because she, too, feared anti-Semitism or perhaps because she did not consider her ancestry an important part of her identity.

Bourke-White's distinctive photographic style established her as a photojournalist and attracted scores of advertising clients. This 1930 picture depicts watch hands in the Elgin Watch Company factory.

Although she chose not to talk about her religious background, Bourke-White's public persona incorporated other traits considered "negatives" by some segments of the business and art

As a correspondent for Fortune, *Bourke-White was the first Western photographer admitted to the Soviet Union, where she photographed the country's rapidly growing industries.*

establishments. She went out of her way to emphasize her youth, sex, and inexperience, turning these possible drawbacks into great assets. In public statements, she shaved two years off her age and failed to mention any of her pre-Cornell photographic work. This created the impression of a young firebrand whose amazing talent had allowed her to produce works of genius almost overnight. As for being a woman, Bourke-White highlighted her femininity with her clothes and her style, delighting in the surprise on people's faces when they saw her scrambling across rooftops in high heels. These tactics helped build the Bourke-White legend. In part, Bourke-White first became famous because she struck people as unique: the "little girl photographer," as the press called her, who took more risks and produced better pictures than older, far more experienced men.

When not on photojournalism assignments, Bourke-White worked for a host of advertisers in her new studio. The Bourke-White Studio rapidly grew into a large enterprise with a full-time staff of eight, including master printer Oscar Graubner. Graubner, who remained with Bourke-White for most of her professional life, deserves much of the credit for the superb quality of her finished prints. As soon as she could afford it, Bourke-White moved her studio to an upper floor of the brand-new Chrysler Building, one of the world's tallest skyscrapers at that time. She loved to say that she had the *highest* photography studio in the world.

Heights had always thrilled Bourke-White. One of her favorite early advertising jobs involved photographing the Chrysler Building's massive tower at each stage of its construction. To complete the assignment, she had gone out in all weather, perching on an open scaffold that swayed in the wind. The strain of this job actually led to her collapse one afternoon, but she recovered quickly and was back on the job the next day. After moving her studio into the Chrysler Building, she occasionally took photographs of the city by crawling out onto the building's steel gargoyles, which projected over the streets some 800 feet below.

Few of her other advertising contracts suited her talents as well as the Chrysler assignment had. Bourke-White believed in making money as well as art—but she knew the difference, and often found her advertising work maddening and downright silly. Besides, as she cheerfully confessed in her autobiography, she never even thought she was very good at advertising work.

Her clients must have thought otherwise though, because the jobs kept pouring in. Bourke-White rarely turned down an advertising client. She knew that she could use her work in adver-

tising to develop her professional skills: skills she could use to tackle any job, large or small, and get it done to specifications and on time.

Bourke-White's two biggest advertising clients were Buick and Goodyear. For Goodyear, she photographed an endless succession of narrowly averted car accidents in which magical Goodyear "margin of safety" saved beautiful women or cute children on tricycles from being run over. Shooting these ads required a major outdoor production, complete with actors and dozens of props.

When not shooting cars and tires, Bourke-White photographed everything from a knight in shining armor to tens of thousands of sticks of chewing gum. Her studio, which already housed two alligators and several turtles that she kept as pets, filled up with a bizarre assortment of the products she photographed: strawberries, sapphires, medieval treasures, auto parts, nail polish, and lobsters.

Many of her contracts called for full-color magazine ads. In the early 1930s, however, a photographer could not simply snap a color picture. Each color print required three negatives—one red, one blue, and one yellow. And for each negative, the camera's shutter had to remain open for several minutes under blinding light. Under these conditions, Bourke-White and her staff had to devise a great variety of strate-

gies to keep perishable products, like food, from spoiling. She wrote that she "often wondered what the readers of women's magazines would think if they knew how the foods pictured in glowing color were handled, squeezed, patted into shape, glued, propped up, mauled, varnished."

Bourke-White welcomed the opportunity to learn about color photography during its infancy, and she often had great fun meeting the challenge posed by the latest soufflé or poached fish she had agreed to photograph. But she never viewed color as her medium. And advertising, especially indoor studio work, never appealed to her as much as her news assignments.

Some of the news events and issues Bourke-White covered kept her away from her studio for months at a time. In the summer of 1930, *Fortune* sent her to Germany to photograph the country's factories. Her first trip abroad, it marked the beginning of the world travels she had dreamed of since childhood.

After leaving Germany, Bourke-White planned to travel east into the Soviet Union, to take pictures of Soviet industry—no easy task at that time. Although American and Soviet business interests had formed many close ties, no Western photographer had been allowed inside the country for years. Bourke-White, however, could not imagine a country more suited to her

On her third trip to the Soviet Union, Bourke-White toured the countryside and was greeted warmly by the Russian people.

style of photography. Fifteen years after its communist revolution, the Soviet Union, a nation obsessed with factories and machines, was trying to make an abrupt transition from an agricultural to an industrial economy. The ban against foreign photographers only made Bourke-White more eager to work there; as she said, "nothing attracts me like a closed door." She was determined to get to the Soviet Union, and to be first.

Fortune's editors were intrigued by the idea of a series on Soviet industry. They gave Bourke-White their blessing, but doubted whether she would gain permission to enter the country. With her usual persistence, Bourke-White

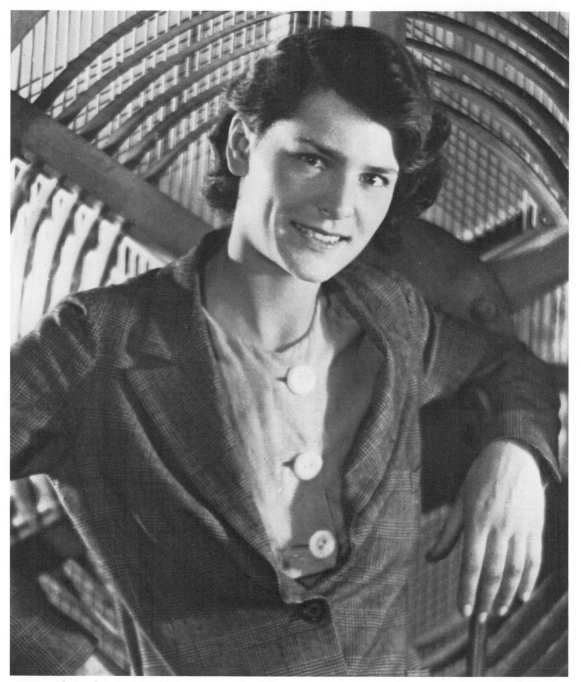

As Bourke-White's reputation grew, the glamorous photographer became as much a subject for the medium as a master of it.

set about getting an entry visa. It took her several months, but the Soviet officials she visited in America and Germany were so impressed by her portfolio that Soviet authorities finally stamped her passport and let her into the country.

Once inside Russia, she faced even more delays, encountering a great deal of trouble trying to obtain the official permits she supposedly needed to travel and take photographs. "Don't worry," the authorities would tell her cryptically, "your photographs will be your passport." The authorities were soon proved right. Everywhere she went, she brought out her photographs of American industry, saying, "Let me take pictures like this in *your* beautiful factory."

Bourke-White made three trips to the Soviet Union in the early 1930s. During her first two trips she toured the country's industrial centers. At each town she visited, she took the kind of photographs she had become famous for—of factories, dams, tractors, and blast furnaces. But by the end of her second trip, she had become just as interested in trying to capture the spirit of the Russian people.

On her third Soviet trip, she decided to tour the countryside instead of the industrialized towns. She had a won-derful time. Escorted by the president of the Soviet state of Georgia, she traveled through the mountains on horseback, sleeping in caves and, when food ran short, dining on fresh lamb roasted on a campfire. The peasants she met along the way had never seen an American before, and wherever Bourke-White stopped for the night, villagers kept her up late with songs, cheers, and toasts.

Bourke-White published her photos of the Soviet Union in *Fortune* and the *New York Times*, and in a best-selling book called *Eyes on Russia*. On one of her trips she also took some film footage, the first to emerge from Soviet Russia. (RKO bought the film and made it into two shorts, but Bourke-White decided that filmmaking was not for her, and never touched a movie camera again.) Combined with her monthly *Fortune* articles, Bourke-White's Soviet photographs made her the best-known photographer in America. The Soviet pictures also heralded the new direction her life would soon take. In the two years following the publication of *Eyes on Russia*, Bourke-White would abandon advertising for full-time photojournalism. And, in her photojournalism, she would turn from the story of industry to the social and political issues of a larger world.

LIFE

NOVEMBER 23, 1936 10 CENTS

Bourke-White was thrilled to be working on the staff of innovative Life magazine. Her photo of the Fort Peck Dam in Montana made history as the weekly's first cover.

New Heights

Given her fondness for travel and her love of high places, it is not surprising that Bourke-White began spending more and more time in airplanes. She took some of her earliest plane trips as an aviation photographer, hired by both Eastern Airlines and TWA to photograph their planes in flight. One such assignment required her to take aerial photographs of passenger planes as they passed over big cities. Strapped into a small open plane, she would fly over, under, and around the larger passenger plane she was photographing. She invited her mother to play one of the passengers on the flight over New York. On the day before the flight, Mrs. White, who was still taking college courses whenever she could, stood up in class and informed her fellow summer students at Columbia that she would be absent the next day, because her daughter would be taking her for her first airplane flight. Just then she suf-

fered a heart attack and fell to the floor. Two days later, she died without ever regaining consciousness.

Bourke-White grieved for her mother, but found solace in the thought that she had died happy. "I believe," she said, "that if Mother had to select the way she should go, she would have chosen such a way as this—eyes looking forward to an ever-expanding horizon, exploring still, even in the last conscious moment of her life."

Soon afterward, on assignment for *Fortune*, Bourke-White found herself barnstorming in another small plane. This time she flew from Nebraska to Texas to the Dakotas, recording the Dust Bowl drought of 1934. The tiny two-seater plane she had hired was ancient and dangerous, and eventually crashed—"but very gently and only after sundown the last day," she reported. In the meantime, Bourke-White and her camera looked down on

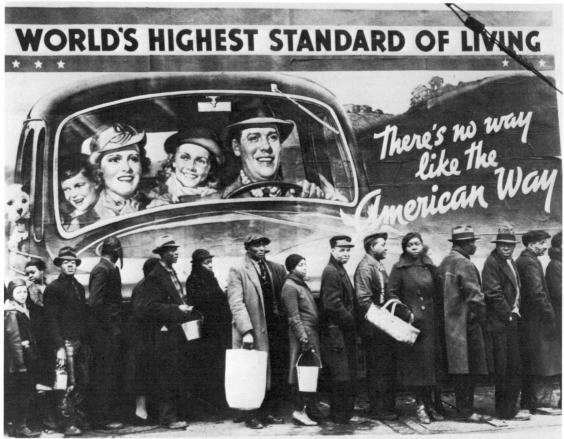

As a photojournalist, Bourke-White developed a sensitive social conscience, revealed in pictures like this ironic shot of Louisville, Kentucky, flood victims standing on a breadline.

the once-rich farmland, which had been utterly devastated by the drought. The crops had withered and the animals were dying of hunger and thirst. The soil had literally turned to dust, which blew and drifted like snow in a blizzard. From her plane, Bourke-White photographed the parched landscape. Then, down on the ground

again, she sought to portray the numb, impoverished Dust Bowl farmers and their families.

Bourke-White found it almost impossible to return from the Dust Bowl to her slick advertising work. By 1936, at the age of 32, she had closed her studio for good and teamed up with Erskine Caldwell to make *You Have*

Seen Their Faces. Not long after completing the book, she left *Fortune* to help launch another of Henry Luce's magazine ventures: *Life*.

Once again, Luce wanted to create a new kind of magazine. Luce conceived *Life* as an inexpensive weekly that would carry news and general-interest stories to a larger public. At the time, several newsweeklies were already on the market, including Luce's own *Time* magazine. But *Life* would take a different approach: It would tell the news through photographs, with words taking second place. With no precedent for this concept of a picture magazine, *Life*'s staff and editors had to make up the rules as they went along.

Bourke-White, thrilled at the prospect of this experimental new magazine, immediately signed on as one of *Life*'s four full-time staff photographers. Just as *Fortune* had done, *Life* gave her the lead story in its first issue. The Fort Peck Dam in Montana served as the subject of her photographs, and the story she produced made photographic history.

Fort Peck Dam was one of hundreds of public-works projects created by President Franklin D. Roosevelt's New Deal program. These projects sought to help lift the country out of the Great Depression by putting people back to work at useful jobs. Henry Luce instructed Bourke-White to fly out to Montana, photograph the construction of the new dam, and look for something "on a grand scale" that might make a cover for *Life*'s first issue.

Bourke-White found her cover: the mighty supports, like castle towers, of the half-finished dam. This cover photograph, with its dramatic abstract forms, was pure Bourke-White, the sort of picture people had come to expect from her. But the story and pictures that accompanied the cover photo came as a surprise even to her editors at *Life*. As they wrote in their introduction, "What the editors expected . . . were construction photos as only Bourke-White can take them. What the editors got was a human document of American frontier life which, to them at least, was a revelation."

Instead of limiting herself to steel and concrete, Bourke-White had explored the homes, bars, brothels, and back alleys of New Deal, Montana, the boomtown that had sprung up around the dam site. The result was a portrait of a way of life. The human interest story included photographs such as one of a barmaid's four-year-old daughter who spent her nights sitting on the bar and playing with the dam's work crew.

Bourke-White's Fort Peck article marked a breakthrough in news photography, or *photojournalism*, as it would come to be called. Once again, Bourke-White had used her camera to help create a new form: an essay that used pictures instead of words to make

its point. This kind of story, soon called the *photo essay*, quickly became a staple of magazine journalism.

Life was a brilliant success. Within a year of its first issue, its circulation had reached 1 million copies, and would have gone much higher if Luce had printed as many copies as people wanted to buy. After another year, it reached more Americans than any other publication. For the next several decades, *Life* remained the most popular of the picture magazines that dominated American journalism, and the photo essay became the general public's primary way of learning about the news.

When *Life* went into publication, it provided Bourke-White with a darkroom and allowed her to bring her own secretary and lab assistants with her. Oscar Graubner, the genius who served as her darkroom technician, joined her at *Life* and became head of the magazine's photo lab. Bourke-White and Graubner both insisted on precise, flawless printing. During *Life*'s early years, they struggled to uphold their artistic and technical integrity in the face of the magazine's weekly deadlines. Together they helped set the technical standard for *Life* and its many imitators.

Bourke-White's association with *Life* was the most important of her career. She did have some differences with its editors, and in 1940 she even quit her staff position, in part because she felt that they had not printed enough of her work. But within a few months she asked to rejoin her "family," as she called it, and *Life* welcomed her back as a part-time contributor. She continued her association with the magazine for the rest of her career.

Life's articles ran the gamut of professional journalism. They included breaking news stories, in-depth features, and strange or amusing articles about American life. In the second half of the 1930s, Bourke-White seemed to go everywhere and see everything on her *Life* assignments. The jobs she liked best were, of course, the most exciting stories—and those that sparked her emerging social conscience.

The Louisville, Kentucky, flood of 1937 was such a story. Flying to Louisville on an hour's notice and landing moments before the airport flooded out, Bourke-White waded through the swirling water and rode a makeshift raft to get her pictures. Nine hundred people died in the flood, and thousands more lost their homes and possessions. Bourke-White traveled throughout the ruined city. She returned with some spectacular photographs, including one that has become famous for its grim irony. In this photo, a straggling line of black people stands waiting to receive food at a relief center. Behind them, a huge billboard of a

happy white family proclaims: World's Highest Standard of Living—There's No Way Like the American Way.

Bourke-White's other early *Life* assignments included a study of the Supreme Court; a portrait of average citizens in Muncie, Indiana; a study of paper manufacturing; and an exposé of Boss Hague, the mayor and virtual dictator of Jersey City, New Jersey. Although Boss Hague encouraged the child-labor sweatshops that proliferated in his city, he did not want them photographed. In order to take pictures of the dark, cavelike firetraps where whole families worked for pennies an hour making artificial flowers, Bourke-White had to hide from Jersey City's 900 policemen. The police soon found her, arrested her, and destroyed all the film in the cameras she carried—but Bourke-White, expecting this kind of treatment, had already smuggled several other cameras out of town, without even stopping to change film as she worked. *Life* ran a big story on the Jersey City scandal, along with a portrait of Hague captioned "I Am The Law!" In later years, Bourke-White enjoyed recalling the way she had beaten Hague at his own game.

Bourke-White's trip to the Arctic Circle with Lord Tweedsmuir, the governor-general of Canada, also counted among her favorite early *Life* assignments. As she explained in her autobiography, in the 1930s the idea of

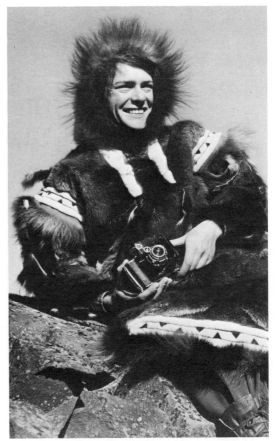

Bourke-White enjoyed her trip to the Arctic and happily adopted the local approach to keeping warm.

going to the Arctic Circle to take photographs seemed about as farfetched as going to the moon. No one even knew exactly how she would find the governor-general's boat, much less take photos in Arctic temperatures under the midnight sun of polar summer. But Graubner made some clever guesses as to what she would need,

During her tenure as a Life *photographer, Bourke-White married Erskine Caldwell. They enjoyed five years of marriage before they decided to divorce.*

Life's editors rented her a small pontoon plane, and Bourke-White set off.

Lord Tweedsmuir invited Bourke-White to join him on his boat, which traveled slowly through the Arctic waters, stopping at remote villages and Eskimo encampments as it made its way north. For Bourke-White, the boat trip provided her with a time of quiet happiness and rare leisure. Between ports of call, she chatted with the genial governor-general and his crew, occasionally took photographs of the landscape, and monitored the progress of her mourning-cloak butterfly chrysalises—the subject of her latest series of life-cycle nature photos. Just as her southern praying mantises had, Bourke-White's Arctic Circle butterflies made a dramatic debut. Everyone on board ship, including the captain and the governor-general, got caught up in the excitement of the event. When the butterflies finally emerged—on Great Bear Lake, near the Arctic Circle—the captain even stopped his ship so Bourke-White could take her pictures without vibrations. Lord Tweedsmuir held up light reflectors for her and joined in Bourke-White's delight when 10 beautiful butterflies fluttered onto the rail of the boat deck.

While on a trip around the world, Bourke-White and Caldwell stopped in Moscow, where they witnessed nighttime attacks on the city by German bombers. Bourke-White considered the pictures she took there some of the best of her career.

When the boat stopped to pick up mail at a settlement called Fort Smith, a smiling radio operator came on board with a telegram addressed to: "Honeychile, Arctic Circle, Canada." After informing her that he and his fellow operators had chosen her as the most likely candidate for the telegram, he gave it to Bourke-White. The telegram read: "COME HOME AND MARRY ME." Signed "SKINNY."

"Skinny," of course, was Erskine Caldwell. For several months he and Bourke-White had been living together—discreetly and, due to her work, sporadically—in New York. Caldwell, a married man when he first met Bourke-White, had separated from his wife and children and wanted a binding promise from his beloved Kit. Bourke-White, however, had many misgivings. Except for her former husband, she had never loved a man as much as she loved Caldwell. But her work came first, and she doubted whether Caldwell could ever accept that. The Arctic trip provided a perfect case in point: Bourke-White had left for the assignment on one day's notice, and Caldwell had not taken the news well. As she wrote in her autobiography, it was not the MARRY ME part of

the telegram that worried her as much as the plea that she COME HOME. Didn't he know she had a job to do?

During that year—1937—and part of the next, Caldwell kept urging Bourke-White to marry him, and she continued to hesitate. In the meantime, they traveled together to Czechoslovakia and Hungary to gather material on the rise of Hitler and Nazism in Central Europe. Aghast at the violence and anti-Semitism they saw all around them, they spent five months abroad, much longer than they had originally intended.

When Bourke-White's photos of the European crisis appeared in *Life*, they created quite a stir in the United States. She and Caldwell also produced *North of the Danube*, a book about the plight of the Czechs and Slovaks as Nazism gained power. Although the book was a popular and critical success, Bourke-White worried that her photographs had not gone deeply enough—that she had failed to provide a full picture of the Czech and Slovak people. She suspected that Caldwell's moodiness and their strained relationship might have prevented her from doing her best work.

Bourke-White and Caldwell returned home to a chorus of reporters' questions about when they planned to get married. To the irritated Bourke-White, it seemed as if the whole world were following the rocky course of their

courtship. Recalling those days, she wrote: "Finally a time comes when it is just too troublesome to remain unmarried." So after a year's resistance, she gave in—but only after getting "this fascinating, gifted, difficult man" to promise that he would try to curb his frozen, silent moods and his jealousy of *Life*.

In 1939 the couple flew to Nevada, where they could marry without a waiting period. Unwilling to get married in one of Reno's flashy wedding chapels, they looked at a map and found a town almost 100 miles away with the romantic name of Silver City. This, they decided, was where they would marry. Undaunted by their cab driver's warning that Silver City was a ghost town, they found a minister, brought him with them in their taxi, and were married that evening in a beautiful, if dusty, Silver City church that had been abandoned for years.

The first year of their marriage was a happy one for Bourke-White, perhaps the happiest of her life. After honeymooning in Hawaii, she and Caldwell moved into a country house in Darien, Connecticut, complete with a garden, tea sets, and cats. They talked wistfully about the child they would have someday—even before their marriage, they had given this dream child a name, Patricia, and had dedicated *You Have Seen Their Faces* to her. The newlyweds discussed the important books

Although Bourke-White had to take and develop her forbidden air-raid photographs in secret, the Soviet authorities permitted her to photograph a Nazi plane shot down over Moscow.

they would write together about the social issues that deeply concerned them both. For a while, at least, Bourke-White believed that she had found her life's companion.

While Bourke-White and Caldwell planned their private happiness, the larger world was falling apart. In September, 1939, Hitler invaded Poland, and England declared war on Germany. World War II had begun. In October, *Life* assigned Bourke-White to England, to photograph the country's preparations for war. That fall and winter she traveled, without Caldwell, to blacked-out London, and then to Romania, Turkey, and the Middle East. She took some memorable photos of both ordinary people and world leaders, and had a string of hair-raising adventures. But she missed her husband who, for his part, was becoming increasingly lonely and resentful back home.

On her next two long trips, Bourke-White and Caldwell traveled together as a photographer-writer team. Their first trip was a cross-country tour of America in the fall of 1940. The couple rode in airplanes, automobiles, and even freight trains, stopping along the way to interview and photograph the people they met. They hoped to learn what was on the mind of the average American as the country lived through the end of the depression and faced the threat of war. Bourke-White sub-

mitted her photographs of the trip to *Life*, but the magazine did not print them. Eventually she and Caldwell published them in a successful book entitled *Say, Is This the U.S.A.?* Even so, Bourke-White regarded these photographs as inferior. She and Caldwell seemed to have lost the ability to bring out the best in each other's work.

The couple's next trip, a voyage around the world, took them across the Pacific, through China, and into the Soviet Union. Bourke-White managed to be the only Western photographer in Moscow when Germany attacked Russia. Bombs began raining down on the city every night. The Soviets announced that photography was forbidden, and the American ambassador advised Bourke-White and Caldwell to leave the country for their own safety. But Bourke-White had no intention of abandoning the biggest scoop of her life.

Like his wife, Caldwell thrived on danger and excitement. In the days that followed, he and Bourke-White worked out a routine. Every night, when the air-raid siren sounded, they hid—Bourke-White under the bed, and Caldwell behind a chair, a bear rug slung over his head—while Soviet air-raid wardens cleared the hotel and led everyone into underground shelters. Then, as German firebombs fell around them, Bourke-White set up her cameras and tripods, and shot pictures

from their hotel balcony. Late at night, she and Caldwell processed the film in secret, using the bathtub-developing techniques she had learned in Cleveland. She sent *Life* a series of spectacular photographs, including a historic nighttime shot of the Kremlin, the Soviet governmental headquarters, illuminated by the sparks of exploding bombs.

Bourke-White returned to America knowing that she had taken some of the best photographs of her life. Her marriage did not fare so well, however. She began working on a book called *Shooting the Russian War*—not a collaboration this time, but her own creation, with her writing as well as her photographs. This must have bothered Caldwell, then plagued with doubts about his own career. As Bourke-White's skill and confidence increased, Caldwell's talent seemed to wane. He became moodier than ever before, and more insistent that she cancel some of her photo and lecture assignments so she could stay home

with him. She refused his requests though—perhaps, in part, because he was so often critical and silent when she did spend time with him in Darien. Patricia, the longed-for child, never arrived.

Finally, while Bourke-White was on another European assignment in 1942, Caldwell cabled her that he could not go on with the marriage. Within months he had gotten a divorce and remarried, this time to a student half his age.

In her public statements, Bourke-White betrayed no resentment or even disappointment over her broken marriage. "We had five good productive years," she later wrote, "with occasional tempests, it's true, but with some real happiness. I was relieved when it was all over, and glad we parted with a mutual affection and respect that still endures." Once again she chose to put the past behind her, and to concentrate on her work. The world was at war, and she set out to photograph it.

The first woman to be accredited by the Pentagon as a war correspondent, Bourke-White fearlessly covered World War II from the air, by sea, and on the ground.

SEVEN

The Front Lines

In the spring of 1942, as Bourke-White and Caldwell separated, the 38-year-old photographer had little time to spare for her personal problems. The United States had entered World War II in December of 1941, and the military had quickly accredited Bourke-White as the country's first female war correspondent. *Life* helped her work out an arrangement with the Pentagon whereby both the magazine and the U.S. Air Force would have access to some of her photos. As Bourke-White wrote, "With my love for taking pictures from airplanes and of airplanes, it was perfect."

Once in military uniform—one specially designed for her, because the Pentagon had never had to outfit a woman correspondent before—Bourke-White flew to England to cover the arrival of the first 13 U.S. Air Force B-17 bombers, which soon began flying missions over Germany. In the months that followed, she photographed all the maneuvers on the base that she thought might get by the wartime censors. She also made several trips to London, where her assignments included portrait sessions with Winston Churchill and Ethiopia's emperor Haile Selassie, who offered to carry her gear for her. King George of England, upon visiting the air base, asked about "that woman with the remarkable hair, who was taking pictures." Bourke-White wrote that "to have a king admire my hair and an emperor carry my cameras was more than I had been accustomed to."

She felt it an even greater tribute when a bomber crew on the base asked her to name and christen their airplane. The christening of the B-17, which she named *The Flying Flitgun*, was carried out with great fanfare. After the bands had played and the speeches had ended, Bourke-White climbed a high ladder and broke a Coca-Cola bottle over the machine gun on the bomber's nose.

Bourke-White enjoyed and was flat-

tered by her role as the base's chief morale booster. But she soon tired of taking photographs at the base, and asked to accompany the *Flitgun* on an actual bombing mission. Her requests got her nowhere: Although male correspondents had been allowed to fly on missions, the air force officers treated Bourke-White overprotectively, refusing to let her go.

As she wrote, "The pain of leaving pictures undone which my magazine needed went very deep. Then something happened so spectacular, so tantalizing, that it overshadowed even the importance of going on a mission. I dropped my request and made another one." Thanks to some friends in high places, this second request—to cover the top-secret Allied invasion of the North African coast—was granted, much to Bourke-White's joy. She knew that she had a scoop with this story: the opening up of the war on a new front, and an invasion so secret that even her editors back home knew nothing of it.

She was hopeful that she would fly to Africa with the bomber squad, perhaps even on the *Flitgun*. But because she was a woman, the military officials insisted that she go to Africa by sea in a convoy, which was supposedly safer. As it turned out, all of the planes reached Africa without incident, but Bourke-White's convoy came under torpedo attack.

She was traveling in the convoy's flagship, a converted pleasure cruiser, along with 6,000 British and American troops, 400 nurses, and 5 WACs— members of the Women's Army Corps, the first American women ever sent on combat duty. On the night before its scheduled arrival in Africa, Bourke-White felt "a dull blunt thud" and knew that her ship had been torpedoed. With the aid of a single flashlight, she and her bunkmates threw on some clothes, grabbed their knapsacks, and rushed for the decks. At first Bourke-White, thinking only of her work, ran to an upper deck, hoping for a trace of dawn that would let her take pictures. Once she realized that work would be impossible, her thoughts turned to survival.

In the distance she heard the captain's voice over a loudspeaker, giving the order to abandon ship. After what seemed an eternity—running along the empty, sloping deck of the sinking ship, crashing into debris and metal wreckage—Bourke-White reached her lifeboat. To her great relief, she saw that it had not been lowered, but then she learned the reason: A splash from the torpedo had flooded the lifeboat, and the crew was debating whether it would float if launched.

While the crew members decided their fate, Bourke-White and her boatmates stood in silence. She noticed two nurses standing near her "trem-

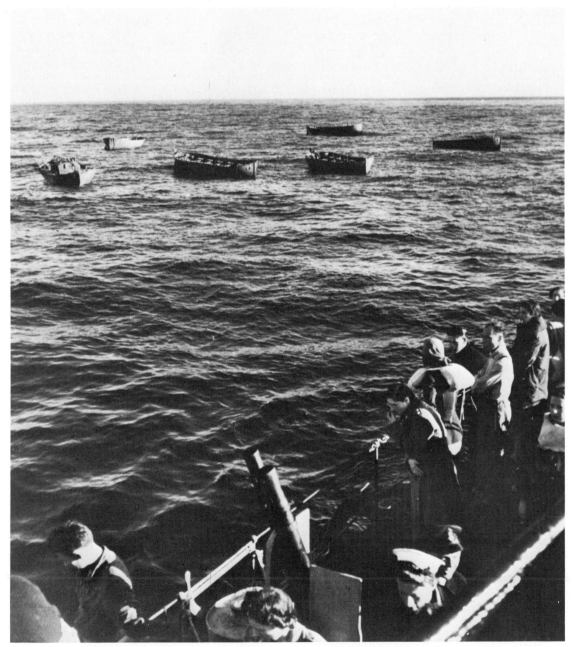

Even when the ship taking her to Africa was torpedoed, Bourke-White could not put down her camera. She took this photograph while an English ship rescued survivors of the attack.

bling from head to foot, with an uncontrollable intensity I had never seen before." Soon she realized that her own mouth had grown dry. She later recalled that a detached inner voice spoke to her, saying: "This is one time in your life when you don't have the faintest ideas what will happen to you.... There's a fifty percent chance that you will live. There's a fifty percent chance that you will die."

Bourke-White would remember the time she spent waiting on that deck as a deep, almost religious experience that changed her life forever, making her feel better able to rise above her own personal problems. As she later described it: "We stood—all 6,000 of us—at a crossroads, not just between death and life, but between paralyzing self-concern and that thought for others which transcends self."

She was inspired as she witnessed the reserves of courage and generosity that ordinary people can draw on in times of catastrophe. She saw WACs who, learning that their lifeboat was overloaded, cheerfully stepped out of line, saying, "Oh, of course, we can't *all* go." Bourke-White's own lifeboat faced a similar problem because of the extra water in it, but the crew decided to take a chance and let everybody board. As lifeboat number 12 finally descended toward the water, Bourke-White hugged a small camera to her—she had jettisoned most of her food rations to fit

As a woman, Bourke-White had to fight for permission to fly on bombing missions. When she was finally allowed to do so, she produced images of war unmistakably stamped with her distinctive style.

it in her bag. All she could think of were the "magnificent pictures unfolding" before her, which the dim light and film technology of 1942 made impossible for her to capture: the ship's "towering hull," the hundreds of people scrambling down its side, and the water itself,

"alive with people swimming, people in lifeboats, people hanging to floating debris." Although some of the people made it to safety, many were swept away.

As the night wore on, Bourke-White and her boatmates drifted aimlessly in the open sea, trying not to think of the waist-deep water that threatened to sink their boat, or of the enemy subs that might still be lurking beneath them. Bourke-White remembered the 1 can of rations she had saved when making room for her camera and decided, for reasons she herself never understood, to wait exactly 11 days before opening the can. But the dawn brought joking from her boatmates, and work for Bourke-White. At sunrise she took out her camera and photographed her fellow survivors; and that afternoon, she had the "keen pleasure" of taking their pictures as they waved to the English boat that first spotted them.

By nightfall, everyone in lifeboat number 12 had been rescued and delivered to hospitals in Algeria. Some of Bourke-White's air force friends found her in the Algiers Maternity Hospital and brought her with them to stay in a luxurious seaside villa that had a brook running through the middle of the house. As soon as she arrived, she was greeted by an air force general she knew. When he heard that she had already experienced torpedo fire, he decided that she might as well "go through everything." She would fly on a bombing mission after all.

Bourke-White flew to her assigned air base in the Sahara Desert and began preparing for the mission. One skill she had to master was the use of the crew's oxygen line. She knew that if she failed to learn oxygen techniques, she would only survive about four minutes at high altitude. She also needed to procure a new set of cameras, because her own equipment had gone down with the transport ship. Fortunately, the air force lent her some of theirs. Bourke-White faced the problem of preparing not only herself, but her equipment, for the shift from the blazing Sahara sun to the subzero temperatures at high altitudes. Bourke-White outfitted herself with a flight suit of leather lined with fleece, and practiced "dragging myself and my cameras around the ship." The air force also issued her a pair of clumsy electrically heated mittens to keep her hands from freezing while she took pictures at 15,000 feet or higher.

The day of her mission, January 27, 1943, dawned bright and clear, perfect photography weather. To her joy, Bourke-White learned that her squad had been assigned a major target: a strategically vital German air base in Tunis. She flew in the lead ship, copiloted by an airman named Major Tibbetts, who two years later would make

history by dropping the world's first atomic bomb on Hiroshima, Japan.

Once airborne, Bourke-White began photographing the crewmen at their posts. By the end of the first hour she had become so completely absorbed in her work that she had forgotten that she was flying on a death mission, or even that she might die herself. When the bomber neared its target, she could see white plumes, black plumes, and flashes of red. Moments later she saw "black spreading spiders, rather pretty, with legs that grew and grew." Without stopping to consider what all this might mean, she took picture after picture, only later identifying the plumes and flashes as Allied bombs, and the spiders as fire from German guns. The Germans hit her plane twice, but caused only minor damage. Two of the planes behind Bourke-White's were not so lucky, and never returned to base.

Life, which brought the war home to millions in those days before television, ran Bourke-White's bombing-mission story as a dramatic lead article. Once again, her own exploits made almost as good a story as the war itself. *Life* printed the bombing pictures under a banner headline—LIFE'S BOURKE-WHITE GOES A-BOMBING—and ran a picture of her in her flying suit—a photo that servicemen soon pinned up in their dugouts and barracks. The war made Bourke-White into a national her-

oine. The tale of the torpedo attack on the convoy flagship inspired at least one movie, and many other movies, plays, and stories featured a plucky woman photographer as the romantic lead.

All this publicity created resentment among some less successful photojournalists. Several of Bourke-White's male colleagues expressed annoyance at what they considered her domineering, high-handed ways. They envied the way in which she always seemed to arrive at the right place at the right time. A few of her colleagues even started to murmur that she had used sexual favors to further her career, though no one has ever offered any evidence to support this allegation. Bourke-White did have several wartime liaisons, including a brief affair with the dashing commanding officer of the bomber squad she photographed, but these romantic relationships were strictly personal. She believed that women, like men, should enjoy sexual freedom, and decided to pay no attention to what people might say about her personal life.

Bourke-White's most serious affair during the war years began in Italy, six months after her return from Africa. This time she wanted to record the war on the ground, to get "the caterpillar view," as she called it. While the bomber pilots had become glamorous heroes in the public eye, few people

paid much attention to the everyday struggles of servicemen down below.

In Naples, a city that had been almost totally destroyed by the Americans and then by the fleeing Germans, she met Major Jerry Papurt, a counter-intelligence officer. Although not particularly handsome, Papurt was a brave, charming, and cultivated man— a psychology professor in civilian life. Bourke-White's recent experiences with Caldwell had once again made her cautious, but she soon fell in love with Papurt despite herself. During the horrifying fall and winter of 1943, she and Papurt saw each other whenever their work allowed. As Bourke-White's biographer Vicki Goldberg recounts: "In that bombed-out city of baroque splendor and squalor, she and Papurt spent their evenings singing songs together off key, wrapped in overcoats in an unheated palazzo, or dancing in a ballroom where the rain dripped through the ceiling." When not dancing or singing, Bourke-White and her lover were risking their lives almost every day. In Naples itself, Bourke-White photographed Italians who, displaced from their homes, lived in caves to escape the bombs overhead. Traveling with the troops to the front, she survived many bomb attacks.

In one of the most heart-wrenching nights of her Italian tour, she photographed the Eleventh Field Hospital as it struggled, under heavy shelling, to

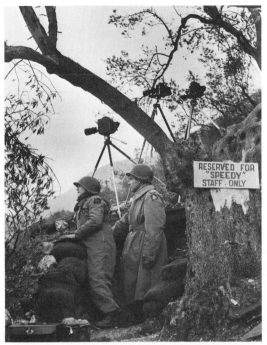

After recording the drama of battle from the air, Bourke-White (left) joined land-based U.S. troops at the Italian front to get "the caterpillar view" of the war.

save what men it could after a disastrous Allied defeat. Bourke-White stood in the operating tent all night taking photographs. By flashlight, wearing protective helmets, doctors and nurses worked on men who had been severely wounded. While the Eleventh operated, part of the operating tent collapsed and an explosion completely destroyed the mess tent, just 30 feet away. When the medical staff had done all it could, Bourke-White and the nurses huddled to-

gether in shared cots, for warmth and comfort. "This way, if we get hit," one nurse said, "we'll die together."

Bourke-White prepared a story about the heroic nurses of the Eleventh and, as always, sent her photographs to the Pentagon for clearance. When she heard the news that the Pentagon had lost them all, Bourke-White "went wild," as she herself admitted. She had risked everything for this story, and she considered it one of the best she had ever done. She even went to Washington herself, conducting her own search of the Pentagon's shelves, but the photos were never found. For the rest of her life, the wound of that loss "remained unhealed."

After returning to the States, Bourke-White spent the spring of 1944 writing

Marching through a defeated Germany with General Patton's troops, Bourke-White photographed bombed-out cities where only a few years earlier she had seen prosperous communities.

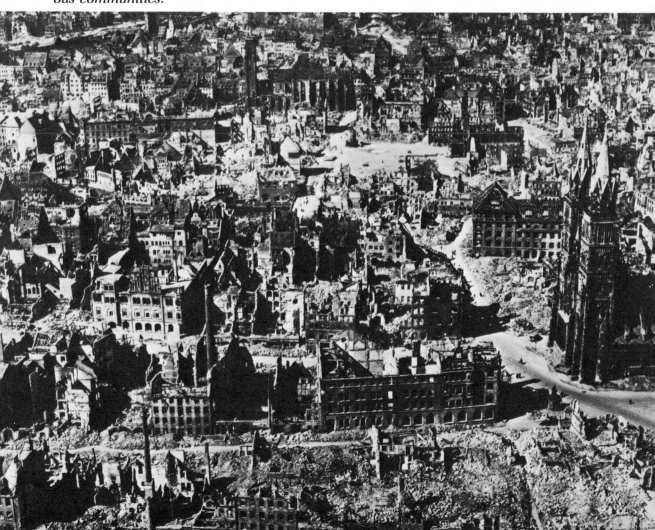

a book about the war in Italy: *They Called It "Purple Heart Valley."* A huge success, the book demonstrated that in Italy she had learned to listen as well as look at the people around her. "Much as I love cameras," she wrote, "they can't do everything. The American soldier with his bitter humor and his peculiar gallantry has opened my ears."

For over a year, Major Papurt had been begging Bourke-White to marry him. He reassured her that he would never resent her work, and that she could always count on his love. When the war took him to France, or *Life* called her home, the lovers wrote to each other at least once a day.

In the fall of 1944, when Bourke-White sailed back to Italy to cover the last of the fighting there, she found a close friend of Papurt's waiting for her on the dock. He told her that Papurt had been wounded and captured. Eventually, Bourke-White learned that the Germans had sent Papurt to a POW hospital. Through the help of a special Vatican department, she managed to dispatch a note to him: "I love you. I will marry you. Maggie." She never knew whether he got her message. That November an Allied bomb destroyed the German hospital, killing him instantly.

Once again, Bourke-White took refuge in her work, photographing the "forgotten front" in Italy, an area all

but deserted by the press several months earlier, when the D-Day invasion had made France hotter news. Bourke-White worked closely with the infantry as it made its way through the frozen winter terrain. Everything around them was white—ice, snow, even frozen waterfalls—so the troops learned to camouflage themselves by whitewashing their clothes, faces, and weapons. Their pack mules wore white sheets on their bodies, and pillowcases with eyeholes cut out on their heads. To Bourke-White, the hooded mules looked eerily like members of the Ku Klux Klan as they advanced by night across the icy mountains.

Bourke-White made "what I thought were 300 exciting photographs," and sent them off. Somewhere between her shooting site and the Naples airport, the photographs were stolen and never recovered. At first she reeled from this blow, but Bourke-White pulled herself together and returned to the front to retake her photos. By the time she arrived, however, the snow had melted and the mules no longer wore their eerie costumes. Although *Life* did use her second set of pictures in a major story, she felt that "nothing was the same."

The war soon offered Bourke-White a new challenge. For most of 1945, she accompanied General Patton's army on its march across Germany. By then the war in Europe was "racing to its

close," as Bourke-White put it. Patton's troops advanced into Germany at dizzying speed. During the first weeks of Bourke-White's assignment, city after city surrendered: The Third Reich seemed to disintegrate before her eyes. "No time to think about it," she wrote. "Just rush to photograph it; write it; cable it. . . . History will form the judgments."

Where once, on her first trip abroad, she had photographed German industry in all its pride, on this tour she saw and photographed the nation's ruined factories, bombed-out cities, and defeated populace. In Liepzig's city hall, she found the mayor, his family, and a host of other local Nazis and their families—all sitting, at desks and on couches, and all dead by suicide. Bourke-White set up her cameras and went to work. "Record it now," she thought, "Think about it later."

That same day a horrible stench led Bourke-White and her colleagues to a small Nazi work camp, strewn with human bones. The retreating Germans had killed all but 18 of the workers in the camp by pouring blazing acetate through the camp factory's windows. Most died in the building itself, but some escaped, "only to die, human torches, on the high barbed-wire fence." To Bourke-White, those who had died so close to freedom seemed the most heartbreaking of all. Without letting her mind absorb what her eyes

were witnessing, she photographed the charred, twisted bodies along the fence. Only later, when she saw her finished prints, did she become fully aware of the horrors she had recorded.

Bourke-White also accompanied Patton's army when it liberated the huge concentration camp at Buchenwald, near the town of Weimar. Patton, outraged by what he saw, ordered his men to round up 1,000 of Weimar's civilians, forcing them to come look at what their leaders had done. Bourke-White photographed the "piles of naked, lifeless bodies, the human skeletons in furnaces, the living skeletons who would die the next day because they had waited too long for deliverance, the pieces of tattooed skin for lampshades." She also recorded the faces of Weimar's citizens as they looked upon the scene. In some ways, her pictures of the civilian onlookers' faces are even more disturbing than her photographs of what they had seen.

As she traveled through Germany, Bourke-White could not stop wondering how the German nation, once so famous for its culture, could have allowed Hitler to achieve such power. She wondered, too, how the war's victors could rebuild Europe and prevent such atrocities from happening again.

The following winter, after she had returned to America, she poured her anger and concern into yet another

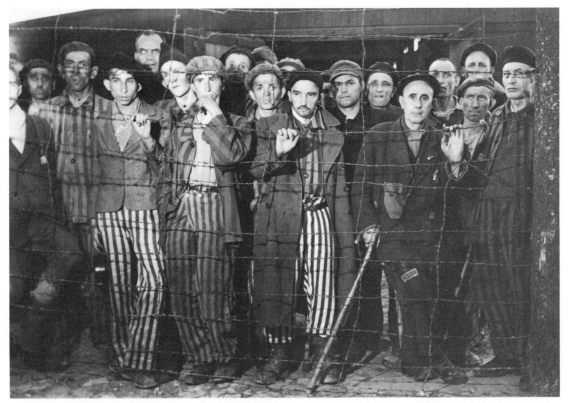

At Buchenwald and other concentration camps, Bourke-White witnessed the liberation of thousands imprisoned by the Nazis. Her photographs of these scenes are a permanent record of the horror of the Holocaust.

book, *"Dear Fatherland, Rest Quietly."* In its text and its photographs, *"Dear Fatherland"* calls on people to consider "the things of the spirit. . . . Unless we do, this war will be without meaning for us, and some of the hope for a good world will die down in the hearts of men everywhere."

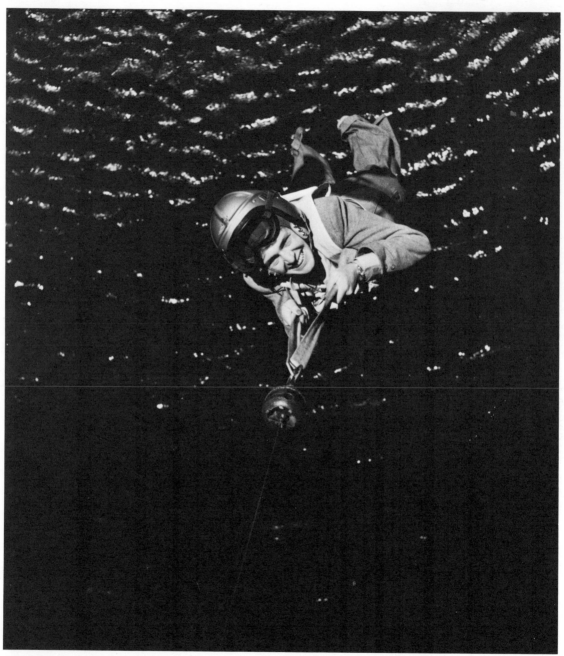

During the last decade of her career, Bourke-White remained bold and energetic in her work, despite the onset of Parkinson's disease in the early 1950s.

EIGHT

Crises Abroad, Courage At Home

When Bourke-White returned from covering the war, *Life* was probably the most influential member of the American media, and the 42-year-old photographer was its acknowledged star. During the next decade she produced some of her greatest magazine photography.

Her work for *Life* took her all over the globe. Between photo assignments, she lectured throughout the United States, always returning to her home in Darien, Connecticut, which she had kept as part of her divorce settlement. With her lecture earnings, she paid off the large mortgage on the house and bought parcels of surrounding woodland whenever she could. The secluded house in Darien was her haven. There, alone except for her hired staff and a bevy of cats, she sorted and evaluated her photographs. She also wrote, often for days at a time, producing books, journals, lecture notes on social issues, notebooks of ideas, and letters by the dozen. Ever since Italy,

Bourke-White had come to rely on writing as a way of digesting her experiences. By the end of the war, she considered herself a professional writer as well as a photographer, and her many readers agreed.

For her first major postwar assignment, Bourke-White covered India's struggle for independence. In the years just after World War II, the Indian people fought for freedom from British rule—not through war, but, led by Mohandas K. Gandhi, through nonviolent civil disobedience. At the end of the decade, however, just as Britain started to cede its rule without bloodshed, violent religious strife broke out between India's own Hindu and Muslim citizens. Some Indians believed that the country could only avoid all-out civil war by creating two nations, one Hindu and one Muslim.

Bourke-White spent the better part of two years getting to know India, and especially Gandhi. When she first met him, she regarded him as a difficult

man, eccentric and out of touch with modern reality. But by the end of their time together, she called him "one of the saintliest men who had ever lived," and considered him a symbol of hope and decency in a world that had produced the atom bomb and the Nazi holocaust.

Bourke-White never forgot the day she first met Gandhi, partly because she had rarely been so irritated. A great believer in the value of simple things, Gandhi spent part of every day spinning cloth by hand. Because he saw the spinning wheel as a powerful spiritual symbol, his staff refused to admit Bourke-White into his presence unless she first learned to spin. Bourke-White, who had a strict deadline to meet, found the whole idea ridiculous, but knew she would have to cooperate in order to get her interview.

Her spinning lesson over, she was escorted into the dim room where Gandhi sat by his wheel, paying no attention to her at all. She was informed that she would not be allowed to use any artificial light—which, in those days of slow film, meant she could take no pictures. After much pleading, her guide allowed her to bring three small flashbulbs. This gave her three chances. After she botched the first, India's intense heat affected her camera shutter and ruined another. Her third try, however, resulted in one of her most enduring portraits:

Lit as if he were illuminated by the glow of his own calm spirit, Gandhi sits reading in lotus position, his slight body dwarfed by the handmade wheel, which seems to stand for India itself.

Bourke-White traveled with Gandhi, taking many more photographs of him. Before long, whenever he saw her coming with her cameras and flashbulbs, he would say, "There's the Torturer again." She liked to think that he meant this as an affectionate joke.

She also covered India's freedom talks, where Hindu and Muslim leaders conferred with the departing British about how to create a unified independent nation. Gandhi and his supporters wanted unity, but Muslim leader Mohammed Ali Jinnah refused, calling on his adherents to resist. When fighting broke out, the streets of India's cities were soon strewn with bodies. Bourke-White flew from Calcutta to Bombay, recording every shocking detail. "The scene looked like Buchenwald," she wrote. "Like Germany's concentration camps, this was the ultimate result of racial and religious prejudice."

Jinnah's side eventually won, and the state of Pakistan—a separate Muslim nation—was created in August of 1947. By then Bourke-White had returned to Darien, where she tried to write a book about India. She soon realized that she did not yet know enough about the country to write a

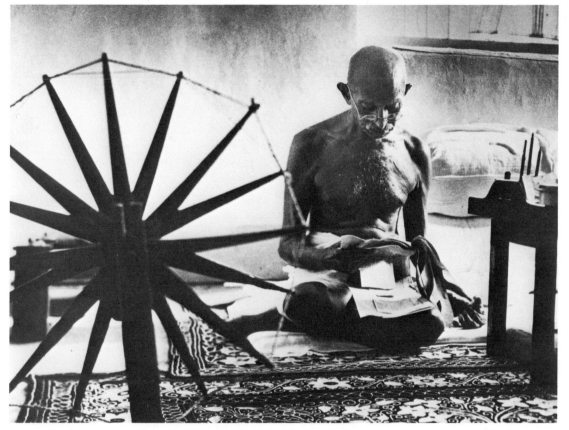

On assignment in India, Bourke-White documented the country's civil strife and met nationalist leader Mohandas K. Gandhi, whom she photographed with his spinning wheel.

thorough account. In late 1947, she prevailed on *Life* to reassign her to India, and for the next five months she and Lee Eitengen, a young woman reporter, traveled across the subcontinent together.

The division of the country into India and Pakistan had left countless Hindus and Muslims living on the wrong side. Members of different reli-gious sects began killing one another by the thousands, and 10 million refugees fled India for Pakistan, or Pakistan for India. Many died along the way. As Bourke-White and Eitengen witnessed these scenes of carnage and misery, they never betrayed any sign of fear or weakness. The men around them fled, wept, or covered their faces to ward off the smell of corpses, but the two

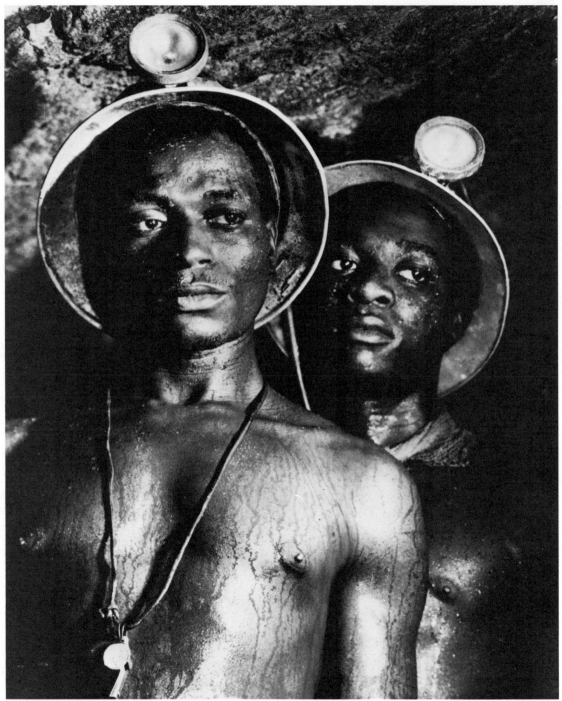

Bourke-White ventured more than a mile underground to photograph black South African miners at work in almost unbearable conditions.

women never did. They wanted to show that women were not unfit for such harsh and dangerous work.

Bourke-White had planned to leave India early in 1948, but she changed her schedule when she learned that Gandhi, now 78 years old and quite weak, had sworn to fast until the warring factions made peace. He was still revered by both the Indian and Pakistani people, and Gandhi's nonviolent tactic succeeded. All sides agreed to his terms. Bourke-White met with him soon afterward and, more than ever before, was struck by his goodness. That same afternoon, Gandhi was assassinated as he walked to a prayer meeting.

After promising to leave her equipment outside, Bourke-White gained entry into the room where Gandhi's body lay. But once inside, she infuriated the Indian friends who had trusted her by taking out a hidden camera and setting off her flash. They ejected her from the room—but she tried to sneak back in and, later, she angered even more people by jumping onto the hood of a truck during Gandhi's public funeral and photographing his flaming pyre.

She left the country soon afterward. In Darien, she worked on her book about India, *Halfway to Freedom*. The book, which took her over a year to finish, contains some of her most thoughtful writing.

While in India, and well into the 1950s, Bourke-White had a number of affairs. She sometimes wondered what life might have been like with a husband and children to comfort her as she grew older. But although tempted more than once, she never married again. She wrote that "a woman who lives a roving life must stand alone," and that she was happy with the way her life had turned out.

In 1949 Bourke-White's "roving life" took her to South Africa, the land of apartheid. For many years she had been concerned with the problems of its people, especially its black majority, who lived under conditions of rigid segregation and near-slavery. As a famous *Life* photographer, Bourke-White had no trouble meeting and photographing government officials and other powerful whites. At first she found it harder to make personal contact with black South Africans until some, who had read *You Have Seen Their Faces* and trusted her because of the book's stand against racial bias, befriended her and introduced her to their friends.

Bourke-White photographed South Africa's landscape and its people, black and white, rich and poor. She witnessed a dawn raid on a black shantytown, where police tore through the compound with guns and clubs, terrorizing men, women, and children. She saw black children forced to work

in vineyards, who were paid, in part, with five daily doses of wine—provided by the landowners in the hope that the children would grow up to become alcoholics and future customers. Seeing those drunken children angered her more than anything she had ever witnessed before.

Scenes like this pointed up a dilemma. "What are the ethics of a photographer? What are you to do when you disapprove thoroughly of the state of affairs you are recording?" Bourke-White later recalled asking herself. Despite her anger, she decided that she could not risk losing her official contacts—and her access to such sights—by protesting an outrage before she had photographed it for the world to see.

Bourke-White took some of her best South African pictures underground, in one of the gold mines crucial to the country's economy. Earlier that week she had met two miners who had put on an exhibition of tribal dances. Struck by the men's grace, she asked their mine superintendent for permission to photograph them at work. He consulted his records on 1139 and 5122—black miners were known not by name, but by the numbers tattooed on their arms—and refused. When pressed, he explained that both men worked in an overmined area deep below the ground, where the risk of cave-ins was too great to allow visitors. When Bourke-White insisted, invoking

the power of *Life* magazine, the official finally gave in.

The next day, she descended into the hot, dark, airless mine. When she saw the proud dancers she hardly recognized them, for their eyes had grown sad and their bare chests dripped with sweat. In the midst of the photo session, she suddenly felt weak and unable to use her voice. When the superintendent rushed her to a more ventilated shaft and gave her water, she revived, but she later learned that a man had died in the mine a week earlier from heat prostration.

As she left the mine, Bourke-White thought about what a mere four hours there had done to her. She was enraged that the black miners often stayed underground for 11 hours a day, before returning to their cramped, windowless barracks to sleep, as she put it, "rolled up like sausages on the floor." She was saddened when she thought about the lives the miners led, separated from their wives and families for years at a time, forbidden even to leave their fenced-in compounds at night without an official pass. But she felt proud of her mine photos—especially a beautifully composed portrait of the two graceful, sad-faced miners.

From two miles beneath the earth's surface, her next major assignment took her eight miles up into the sky. In the spring of 1951, *Life* sent her to photograph the bomber planes of the Strategic Air Command. That fall, she

Bourke-White went to great lengths to shoot unique pictures of the war in Korea and portray the human side of the conflict.

In 1952 one of Bourke-White's Life *assignments sent her to Tokyo, where she observed riots that ensued when Allied forces occupied Japan after World War II.*

also took pictures of U.S. Navy helicopters on rescue practice. During the assignment her helicopter crashed into the Chesapeake Bay; she escaped sinking with it only because, having neglected to fasten her seat belt, she was thrown clear, into the water.

To her utter amazement, Bourke-White found that her work with military planes had made her a target of an anticommunist witch-hunt. In a series of newspaper articles, conservative columnist Westbrook Pegler, maintaining that the army and navy should never have given her clearance to board their warplanes, charged that she had pro-Russian, anti-American sympathies. According to Pegler, Bourke-White's books were communist propaganda, the causes she had worked for were "communist fronts," and her early interest in the Soviet Union made her highly suspect.

Bourke-White knew that Pegler's charges were absurd. But she also knew that he and others like him could ruin her career. The early 1950s saw the dawn of the cold war and the compilation of blacklists of suspected communist sympathizers by Senator Joe McCarthy and other self-styled patriots. Many loyal Americans were losing their jobs and even their friends because of allegations like Pegler's.

At that time, America was mired in a war against communists in Korea, with no victory in sight. After several anxious months, Bourke-White decided

that one way she could clear her name would be to go to Korea on assignment for *Life* and return with patriotic stories. It took some convincing, but she finally won the *Life* assignment she wanted, as well as some backing from military men who had admired her World War II reporting.

Once she arrived, though, she still needed a splashy, original story to cover. Other photographers and writers had already done all the usual wartime articles about major battles, rallies, and peace talks. But Bourke-White had heard about a new kind of warfare: guerrilla fighting in remote hills and villages, in which small, loosely organized bands would hide out in the countryside, make their raids, and then scatter. Villages and even families were sometimes divided by individuals' loyalties to different guerrilla bands.

Bourke-White decided to cover the guerrilla action. For several months, she disappeared into the Korean wilderness, traveling with small, pro-U.S. Korean police forces. She braved typhoons, gunfire, and at least one ambush that nearly killed her. This may have been the most harrowing trip of her career: Nobody back home knew where to find her, and the Communist guerrillas had put a price on her head.

One morning, a local police captain captured a Communist guerrilla who wanted to surrender, saying that other Communist fighters had beaten and

abused him. The bedraggled prisoner, Nim Churl-Jin, longed to go home, but feared facing his older brother, who supported the anticommunists. Nim missed his wife and family, but most of all he wanted to see his mother, who for two years had thought him dead.

Bourke-White immediately decided that she had found the great story she had been searching for. If she could photograph Nim's return to his village, she could show *Life*'s readers what the war really meant in human terms. And by focusing on Nim, the repentant communist, she would prove her own patriotism and refute Pegler and his cronies.

Bourke-White persuaded the police to let her take Nim home. She also made them promise not to let Nim's family know that she and Nim Churl-Jin were on their way: She wanted to capture his mother's expression when she first saw the son she believed was lost forever.

After two days on the road, she and Nim arrived in his village. Bourke-White photographed him meeting his wife and holding the two-year-old son he had never seen. But the mother was visiting relatives several miles away, and would not return home until night-fall. To the single-minded Bourke-White, this seemed catastrophic. Bent on getting her mother-son reunion shot during daylight hours, she bundled poor Nim back into the jeep and set off along the narrow footpath where they hoped to encounter his mother.

Instead of his mother, they came upon Nim's older brother—his political enemy. The brother, although hurt and very angry at Nim, seemed ready to forgive him. He climbed into the jeep next to Nim and Bourke-White and, just before sunset, the three of them noticed an old woman dressed in white walking toward them across the rice fields.

"In a whole lifetime of taking pictures," Bourke-White wrote of that evening, "a photographer knows that he will take one picture that seems the most important of all. And you hope that everything will be right." For this shot, everything did go right. The fading sunlight shone down softly. The mother dropped her walking stick, ran to her son, and cradled him in her arms, crying, "It's a dream, it can't be true." When Nim Churl-Jin answered, "No, Mother, it is not a dream," his mother began to sing, her son in her arms, and Bourke-White snapped what she considered the most significant photograph of her career.

In January, 1953, after almost nine months in Korea and Japan, Bourke-White returned to her home in Darien. Not yet 50, and still at the peak of her career, she continued to photograph, write, lecture, and receive many awards and honors. In the summer of 1953, she began work on a long photo

essay for *Life* about the Jesuit priesthood. She made many friends among the Jesuits, and found her work with them very rewarding. Two years later, she collaborated with a distinguished Jesuit editor to produce a full-length book about the order, called *A Report on the American Jesuits*.

But, although she kept it a secret, it had become much harder for her to go out on assignments, and even to operate her own camera equipment. At first she noticed only that her left leg, which had suffered from mysterious aches since Korea, would not always obey her mind's orders. Then she began to have some trouble walking, and the pain started to spread into her left arm and hand. For the next two years, she secretly visited one specialist after another, but none of them could tell her what was wrong with her.

Thanks to one of the few friends she had told about her problem, she finally consulted a doctor who could identify her illness. Although her doctor was reluctant to name her ailment, fearing that she might become discouraged, Bourke-White soon discovered that she had Parkinson's disease, a neurological disorder that attacks the part of the brain that controls movement. At the time, doctors could do very little to stem the progress of the disease as it advanced slowly and steadily. Parkinson's leaves the mind intact but the body helpless, sometimes shaking or

This picture of Bourke-White was taken in 1957, the year she completed her last assignment for Life *magazine. Though she was only 53 years old, debilitating Parkinson's disease forced her to retire.*

rigid. But with rigorous physical therapy, patients themselves can often retain some control over their movement at least for a while.

Bourke-White's doctor assigned her to a physical therapist, who showed her how to crumple newspapers in her fists and wring out wet towels to try to strengthen her hands. At first she refused, calling the therapy silly and maintaining that she was still "Maggie the Indestructible." Within a few weeks, she realized that she could no longer operate her electric typewriter. From then on, she did her exercises

In her final years, Bourke-White spent most of her time at home in Darien, Connecticut, where she continued to write until a few years before her death.

unfailingly. She could still travel and do some work, and tried to keep her condition a secret. But wherever she went, her assistants would discover piles of crumpled newspaper near her on the floor. They noticed that she leaned on them for support and asked them to reload her cameras. And when she stayed at a hotel, the bathroom quickly filled with sodden, twisted towels.

Bourke-White fought against Parkinson's disease for almost 20 years. Her last *Life* photo essay appeared in 1957, when she was 53. She would write, off and on, for many more years. Work on *Portrait of Myself*, her fascinating (if somewhat one-sided) autobiography, kept her spirits up from 1955 until its publication in 1963. By then she could hardly use her hands, and had trouble walking, speaking, and keeping her balance, but she managed to dictate notes for a sequel to her autobiography, a few words at a time.

As her body failed, her courage and optimism seemed to grow. She underwent two risky, experimental brain operations, insisting after each one that she had at last arrived on the road to recovery. At one point she even asked for, and received, an assignment from *Life* to go to the moon "as soon as we could get transportation."

One of the most famous photo essays of Bourke-White's life featured her as the subject, rather than the photographer. After her first operation, her dear friend Alfred Eisenstaedt, another of *Life*'s talented, original photographers, began taking pictures of her as she went through her daily round of rehabilitation therapy. Her hair had been shaved for the brain surgery and had grown back in a crew cut. She practiced her speech and typing, crumpled her newspapers, and tried to dance and catch a ball.

Bourke-White decided to allow Eisenstaedt to publish his photos in *Life*. After years of secrecy, she wanted to tell her story to the world. With Eisenstaedt's photos and her own text, the story of Bourke-White's illness reached millions of *Life* readers in 1959. The following year, she served as a consultant for a television drama about her fight against Parkinson's disease. Fascinated by television—still a new medium in 1960—she seemed to know by instinct how to work with television cameras.

In the summer of 1971, Bourke-White fell and cracked several ribs. The fall left her unable to move. Within days, her body had become totally rigid, and 2 weeks later she died at the age of 67. Although her last years had been hard and often lonely, Margaret Bourke-White had waged a brave and gallant battle—one of her best. Her life had been that of a fighter determined to accomplish whatever she set out to do; her work had been that of a master, whose brilliant talent helped the world see itself more clearly.

THE WORKS OF MARGARET BOURKE-WHITE

EYES ON RUSSIA. New York: Simon & Schuster, 1931.

YOU HAVE SEEN THEIR FACES. New York: Viking, 1937. With Erskine Caldwell.

NORTH OF THE DANUBE. New York: Viking, 1939. With Erskine Caldwell.

SAY, IS THIS THE U.S.A.?. New York: Duell, Sloan and Pearce, 1941. With Erskine Caldwell.

SHOOTING THE RUSSIAN WAR. New York: Simon & Schuster, 1943.

THEY CALLED IT "PURPLE HEART VALLEY". New York: Simon & Schuster, 1944.

"DEAR FATHERLAND, REST QUIETLY". New York: Simon & Schuster, 1946.

HALFWAY TO FREEDOM: A STUDY OF THE NEW INDIA. New York: Simon & Schuster, 1949.

A REPORT ON THE AMERICAN JESUITS. New York: Farrar, Straus, and Cudahy, 1956. With John LaFarge.

PORTRAIT OF MYSELF. New York: Simon & Schuster, 1963.

FURTHER READING

Callahan, Sean, ed. *The Photographs of Margaret Bourke-White.* New York: New York Graphic Society, 1972.

Goldberg, Vicki. *Margaret Bourke-White: A Biography.* New York: Harper & Row, 1986.

Iverson, Genie. *Margaret Bourke-White, News Photographer.* Mankato, MN: Creative Education, 1980.

Siegel, Beatrice. *An Eye on the World: Margaret Bourke-White, Photographer.* New York: Frederick Warne, 1980.

Silverman, Jonathan. *For the World to See: The Life of Margaret Bourke-White.* New York: Viking Press, 1983.

CHRONOLOGY

June 14, 1904	Margaret Bourke-White born in Bronx, New York
1906	Moves to Bound Brook, New Jersey, with family
1921–22	Attends Columbia University; takes first photography course
1923	Transfers to the University of Michigan at Ann Arbor
1924	Marries Everett Chapman; moves to Indiana and enrolls at Purdue University
1925	Moves with Chapman to Cleveland, Ohio; enrolls at Case Western Reserve University
1926	Separates from Chapman; moves to Ithaca, New York; enrolls at Cornell University
1927	Graduates from Cornell University; moves to Cleveland, Ohio Opens first photography studio
1928	Photographs Otis Steel Mills
1929	Joins staff of *Fortune* magazine
1930–33	Visits Germany and Soviet Union; photographs Soviet industry
1936	Begins work with Erskine Caldwell on *You Have Seen Their Faces* Leaves *Fortune* magazine
1937	Signs on as staff photographer for *Life* magazine
1938	Travels to Czechoslovakia and Hungary with Caldwell Writes *North of the Danube*
1939	Marries Caldwell
1942	Separates from Caldwell; is certified as first American woman war correspondent
1943	Becomes first woman to fly on a bombing mission with U.S. Air Force
1943–45	Covers World War II in Italy; writes *They Called It "Purple Heart Valley";* Accompanies General Patton's army through Germany
1946–49	Travels to India twice; writes *Halfway to Freedom*
1949–50	Covers South Africa for *Life* magazine
1952–53	Covers Korea and Japan; notices first symptoms of Parkinson's disease
1953–55	Photographs the Jesuits for *Life* magazine; collaborates on *The American Jesuits*
1957	Completes last photo essay for *Life*
1959–61	Undergoes treatment to slow the spread of Parkinson's disease
1963	Publishes *Portrait of Myself*
August 27, 1971	Dies in Connecticut

INDEX

PICTURE CREDITS

The Bettmann Archive: pp. 24, 28, 31(top), 36, 37, 38, 39(left and right); Margaret Bourke-White/*Life* magazine, Time Inc.: pp. 3, 15, 17, 18, 21, 48, 51, 57, 61, 62, 68, 70, 75, 83, 87, 88, 91, 92, 95, 96; Alfred Eisenstaedt/*Life* picture agency: p. 104; Estate of Margaret Bourke-White: pp. 27, 31(bottom), 32, 34, 84, 100; Estate of Margaret Bourke-White/*Life* magazine, Time Inc.: pp. 45, 52, 54, 56, 59, 65, 73, 99; Library of Congress: p. 77; *Life* magazine, Time Inc.: pp. 74, 80; Carl Mydans/*Life* magazine, Time Inc.: p. 12; UPI/Bettmann Newsphotos: pp. 60, 66, 103

Carolyn Daffron is a writer and lawyer. A graduate of the University of Chicago and the Harvard Law School, she now lives in Philadelphia with her husband and young son.

Matina S. Horner is president of Radcliffe College and associate professor of psychology and social relations at Harvard University. She is best known for her studies of women's motivation, achievement, and personality development. Dr. Horner serves on several national boards and advisory councils, including those of the National Science Foundation, Time Inc., and the Women's Research and Education Institute. She earned her B.A. from Bryn Mawr College and Ph.D. from the University of Michigan, and holds honorary degrees from many colleges and universities, including Mount Holyoke, Smith, Tufts, and the University of Pennsylvania.